What Almost Happened to Hedy Lamarr
1940-1967

"Children begin by loving their parents;
As they grow older they judge them,
Sometimes they forgive them."
Oscar Wilde

by Devra Z. Hill
with contributions by Jodi Babydol Gibson

Corona Publishing

Published by Corona Books
www.coronabooksandmusic.com2008;

ISBN 13: 978-0-9792202-5-8

ISBN 10: 0-9792202-5-4

CREDITS

Editor: Jody Babydol Gibson

Front Cover- Artwork: Jody Babydol Gibson

Style/ Concept: Jody Babydol Gibson

Photo: George Hurell

Back Cover Style/ Concept: Jody Babydol Gibson

Photo: Personal Devra Hill

Acknowledgments

I would like to thank my Corona Books Publisher, Jody Babydol Gibson, for helping me break through outdated rules that were creatively limiting the final completion of "Image."

Devra Hill

Table of Contents

Preface

Hedy was a Hollywood Sex Goddess in the Golden Age of Hollywood, the 1940's and '50's. If you were a star then you were royalty. You set your own morals and rules and got away with it because the Fan Magazines were not Tabloids. Nobody could really live up to their screen image but that was the word actors lived by "Image."

I met Hedy in August 1965 when I was a writer for the Fan Magazines and she asked me to write her Biography but about 6 months into working on the book she got arrested for shoplifting and I decided not to continue.

Other stories have been written about Hedy but they didn't have all the shockingly interesting details she told me. Recently I found my notes again and thought they would make a great novel with some of her true stories combined with my writers' creative imagination. If Hedy were alive today she'd say this story would make a fascinating movie.

Hedy's English was sometimes precarious and she'd say very funny things like when she asked me to go to a party with her she said, "You're a Redhead and I'm a Brunette and we'll compromise each other!" I laughed knowing she meant, "We'll compliment each other."

Hedy came to Hollywood from Austria after making only one international film. A film so shocking in those days it showed her nude and enjoying sex; behavior unheard of in America, especially for a classically beautiful woman. She used her beauty to reach goals few women ever attained in the world of fame and fortune.

Studio mogul, Myer Beldin, signs her to a contract and tries to control her life the way he controls his studio. In the end, she controls him. She also meets another mogul, Anak Stanislaus, a man with the same selfish greed as Beldin but he has Continental Savoir-Faire and extraordinary wealth from his Greek shipping industry businesss. Now he wants to buy a film studio because he believes films are a subtle form of propaganda that could bring him world control.

Because Hedy married at 17 and her first husband was a Sadist she was already jaded by the time she reached Hollywood at 20.

Hollywood did not improve her opinion of the human race. In my Novel she soon finds another man she considers worthy of being her second husband. He's a member of British Royalty but to her chagrin she finds out he prefers another man; a blow to any actress' ego. But she does manage to have a daughter by him.

This marriage ends bitterly but it's not long before she finds another husband, a Psychiatrist who she drives crazy. In her heart she wants to return to Germany for revenge against her first husband.

During Hedy's years in Hollywood she reigns supreme in films and her daughter, Brana, grows up to be a beautiful, loving girl who wants to make the world a better place to live in.

In College Brana falls in love and gets engaged but later learns that Hedy has ruined her relationship. Then Brana decides to join the Peace Corps and volunteers for work at a hospital in Africa.

As fate would have it Hedy's actress ego is her undoing. By the 1960's she is a "has been" but before that time she does manage to get revenge against her Sadist first husband.

Later she's not ready to be a "has been" and she finds a part in a new film that is perfect for her and could possibly revive her career. Ironically it's to be filmed in Africa where Brana is working in a Medical Clinic and has found peace of mind until Hedy arrives.

Although Hedy has conquered the Hollywood Jungle it is the African Jungle that takes it all away from her. Fortunately Hedy leaves behind a living legacy, the best part of what she might have been, her daughter.

Chapter 1

HOLLYWOOD, 1940's

The lust for power is not rooted in strength but in weakness.

Erich Fromm

"**A** woman of rare beauty, don't you agree?" A slim Chinese banker was speaking to a portly Englishman.

"Very rare," replied the Englishman stoically, then lowering his voice he said, "I presume you've heard about that film she made in Germany?" He peered over his horn rimmed glasses with raised brows.

"I heard but I wasn't fortunate enough to see it. They say she had an orgasm on screen. Oh, that's her now."

Hedy had just entered Myer Beldin's Sunset Towers penthouse, gliding in wearing a floor length low cut red chiffon gown. The intimate group of 20 potential investors turned to stare at the woman Beldin was grooming for stardom. Hedy's reputation had preceded her and all the Shylocks attending wanted their pound of flesh.

Hedy smiled a greeting and moved to Beldin's side. He kissed her cheek and was again overwhelmed by the awesome perfection of this exquisite woman. Her finely chiseled nose, the high cheekbones and green eyes over full lips all framed by auburn hair parted in the middle. She was a perfect picture for the camera to capture.

"You look lovely my dear," he smiled.
Although Hedy was accustomed to excess attention she never tired of it. And now at 20 her own self-involvement seemed to generate more interest from others.

Myer Beldin began introductions. "Hedy, this is Anak Stanislaus, President of Athens Enterprises. Anak only owns half of Greece but I own all of Hollywood!" Beldin winked and put his arm around Hedy's waist.

Anak kissed Hedy's hand, his eyes never leaving hers and said, "A slight exaggeration in both areas." He looked at the diamond necklace resting on Hedy's ample bosom then back to her face.

"I met your husband Gunther in Paris through a business transaction and helped him pick out that necklace for you. I'm sorry I didn't have the opportunity of meeting you then because you're even more beautiful in person than on film."

Beldin looked a bit nervous and said, "So you like my find, Anak."

Anak nodded, "Yes you are a master at finding talent."

Tita Harris, a syndicated newspaper columnist interrupted. "Hello, I'm Tita Harris, Hollywood Tattler." She extended a gloved hand and Hedy shook it. "Hedy, I admire your adventurous spirit, coming to Hollywood a l'improviste." Tita cooed but Hedy detected underlying jealousy.

"I'm sure it will be worth the risk," Hedy smiled thinking of how she had to run away from Gunther like a thief in the night.

Tita looked at Hedy like a vulture about to pick apart its prey. "I saw your film while I was in Europe. I guess Germany doesn't have a censorship problem?"

"That film was made when I was only 16. I was an innocent victim of an unscrupulous director."

Tita raised her eyebrows, "Not so innocent."

Beldin coughed, "Excuse us, Hedy needs to meet HoChu." He pulled Hedy away and introduced her to the Chinese banker and Englishman in quick succession. After some small talk Beldin

pulled her to another group. But before they got to them Hedy said, "That film haunts me."

"Relax, my dear; that film is your stepping stone to stardom but with our censorship most Americans will only hear about it. And that's even better because their imaginations will run wild."

Tears began to well up in Hedy's eyes, "That Tita talks to me like I'm a whore."

Beldin patted her arm, "She's just jealous. Look at her pockmarks and wig. Don't worry about the past, only the future because that's where you'll be spending the rest of your life."

His philosophy didn't placate Hedy who turned and hurried past a chattering group then disappeared out the door. Anak noticed her hasty exit and followed her.

Hedy was already in the elevator so he raced down the stairs and as she alighted grabbed her arm.

"What are you doing?" she protested.

"Whatever you're doing," he smiled.

"I want to be alone."

"Only Garbo can get away with that line." He guided her outside to a silver Rolls Royce parked at the curb. Once inside he opened a special compartment, poured 2 shot glasses of Cognac and handed one to her. They both drank the Cognac and then he started the car.

"Where are we going?" she asked.

"I thought a little drive to the beach might calm your fears, whatever they are."

She sighed leaning back against the leather seat; her throat still aching with unused tears.

As they approached the beach Anak glanced at her, "When

I first saw you, you looked so sophisticated, a woman of the world. But now you're almost childlike."

Hedy had a faraway look as she stared at the ocean. "Could we walk along the beach?" she asked quietly.

Anak hopped out of the car and walked around to open the door.

She looked at him wistfully, "I suppose you saw my film."

He smiled, "It was beautiful and exciting, just like you."

She sighed, "I did everything too young."

"You make it sound like your life is over instead of just beginning."

She sighed, "I've already lived a lifetime. Everything was so simple until I turned 13 and men started looking at me differently."

"Yes, I'm sure they did," he said as they began to walk along the beach.

She looked at him. "You must know what's going on in Germany now; hatred everywhere. Hitler has Chamberlain fooled telling him that the Nazi's are peace loving. What rubbish! To the Germans he preaches Aryan race superiority and the Germans believe him. The whole country is dead. Ohne allen anlass."

"Yes, all without reason," he translated her German. "How does Gunther feel about it?"

"He is very much involved with his steel factory and looks forward to the profits of war. But I have left him and I will be filing for divorce here. Now I do feel like walking on the beach."

As they began to stroll down the beach she stopped to take off her high heels. It was a warm balmy night and the Santa Monica Pier glittered with brightly colored lights as they approached from below. Then they saw two men in the shadows

underneath the pier. A large, muscular man was hitting a smaller effeminate youth.

"Wait," Anak said pulling Hedy back protectively. Just then the large man glanced up and yelled something obscene while pulling a switch blade knife from his pocket and approaching them.

"Come on," Anak said, "he doesn't look friendly." But when he glanced at Hedy he saw a fascination in her eyes that startled him. She seemed riveted to the spot as the man approached.

"Oh God," Anak mumbled, realizing she had put him in the position of defending them. In an instant he pushed Hedy back and kicked the man in the groin.

The man dropped to his knees swearing but then the youth came screaming at Anak and tried to scratch him. Anak punched him in the stomach and he fell to the sand. Then Anak grabbed Hedy and practically carried her back to the car.

Once inside he fell back exhausted. He looked at her and a chill ran down his spine. "Do you realize we could have been killed?"

She shrugged but said nothing so they drove back to Hollywood in silence. When he got there he asked, "Where are you staying?"

"Myer gave me a flat in his apartment building, where we had the party."

"That's convenient," Anak smiled.

"Oh, but he doesn't live there, he has an estate in Bel Air."

"I know, with a 10 foot high fence and Dobermans guarding." When he pulled up in front of the building he asked, "May I come in for a nightcap?"

She shook her head, "No, I'm very tired."

"You'll miss me when I leave for Athens in a few days. Who will protect you?" he grinned.

She eyed him thoughtfully. He wasn't really handsome but with his swarthy skin and black curly hair he had an animal magnetism. "Alright, come up, but only one drink."

He hurried around to open the door for her. As they entered her apartment she noticed a cablegram on the floor. Picking it up she motioned to a bar cart, "Help yourself," she said while tearing open the cable. It read, "Hure komn heim! Gunther" (Whore come home, Gunther)

She mumbled, "Kuppler" (Pimp) under her breath. Didn't he realize by now that she was no longer his to command?

"Bad news?" Anak asked as he poured himself a Scotch and turned on her radio to the soft music of "Fools Rush In."

She sighed and slumped down on a couch. "Gunther is always bad news. Well, it didn't take him long to find me. But, no matter, soon I'll be rich and famous and as powerful as him. Beldin promised me that."

"Of course," Anak sat down beside her. "You're a good investment and a safe bet. But don't worry, not even Hitler could get to you here. Last month the British did a magnificent job of pushing him back. They're already calling it the Battle of Britain."

An involuntary shiver passed through her as she remembered her evenings with Der Fuhrer after hostessing some dinners for him he showed a sexual interest in her. Then Gunther forced her into an orgy with Hitler because he wanted to please the man who gave him millions for war supplies. He also wanted to watch and be stimulated in to joining them. What surprised her even more was that although she was "forced" into this tryst

with Hitler, she found herself drawn to him. In addition to his odd idiosyncrasies, the fact that he had only one testicle did not seem to wane her interest either. Ever the resourceful one Hedy just worked around it. She wondered what was it about powerful and abusive men that somehow turned her on? He seemed to enjoy her as well judging by some of the gifts he bestowed upon her. In appreciation Hiter had given her a solid gold cigarette case with a Swastika emblem of studded diamonds on the top. Just thinking about it made her frown and shiver.

Anak noticed her reaction and asked, "Do you really think Hitler has the courage to fight the whole world?"

"Courage?" she shook her head, "Madness, Yes!"

Anak downed the rest of his Scotch. "Well Hedy, I challenge you to a dinner before I leave for Athens."

"Challenged, she half smiled, "Perhaps. Call me tomorrow night." She was dismissing him.

He stood up, "Forgive me, a Gentleman never tires a lady unless in bed. He winked and walked to the door.

She extended her hand and he brought it to his lips but didn't kiss it, merely looked up at her roguishly and clicked his heels. "Guten Abend." (Goodnight)

She looked surprised as her phone rang. Anak left as she went to answer it. Beldin's voice boomed, "Where the hell have you been?" Then his voice softened, "My dear, you must not be so sensitive about your film. You're going to be a Superstar. You have got to accept jealousy for what it is."

"I'm very tired now," she sighed.

He guffawed, "I'm not surprised, Tita told me you left with Anak. I don't want you to wear yourself out before you start working. I've invested in you and I expect loyalty."

"Heil Hitler," she said and hung up.

Beldin stared at the phone for a moment then mumbled, "I'll damn sure have to stop her from saying that in this country." Then he hung up and thought I'll have to get my lawyer to draw up her contract tomorrow.

Hedy went into her bedroom and undressed. She wondered if Gunther had hurt her maid Hedwig? He'd probably figured out that she had helped her escape. Then she slipped on the brown satin robe that had been Gunthers and ran her fingers over the heavy embroidered initials on the breast pocket. For a brief moment she longed to feel his hand across her backside. She shivered. That was ridiculous. She hated him. She needed to be the sweet girl she was when they met. It wasn't too late to begin a new life…or was it?

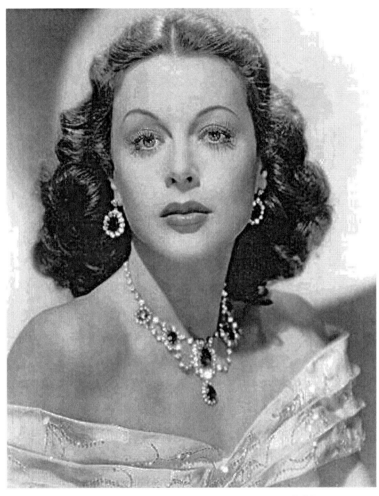

HEDY LAMARR COMES TO HOLLYWOOD

Chapter 2

TRUE FRIENDS

A true friend helps us to appreciate ourselves better!

The next morning Beldin called early.

"I'm sending my secretary, Mary, over with a car and chauffeur so she can take you shopping and then back to the studio to sign the contracts studio to sign the contracts.

"Fine," Hedy said and hung up.

Then Anak phoned, "Good morning, beautiful, I've decided to show you Hollywood this weekend. We'll start at the Pirates Cave and see my friend Hank Grant. He's the MC and singer there. It's a nightclub owned by a few local fellas who pooled their pennies together."

Hedy was annoyed by his audacity, "I'm not interested in going to some smokie nightclub with your poor friends."

He laughed, "Well now you might have heard of these friends, Bob Hope, Rudy Vallee, Ken Murray, Bing Crosby and a couple of hopefuls." But Crosby and Hope won't be there. They're on the "Road to Morocco" with Dorothy Lamour.

Hedy couldn't help but laugh.

"Well you just may have a sense of humor buried inside. Oh, they've also got a comedian named Doodles Weaver who nearly set the place on fire last night roasting wieners in his dressing room. But if that doesn't warm you up we could go see the Monkeys at the Cocoanut Grove and after that I'd like to show you an East Indian Magic Palace."

Her doorbell rang and she yelled, "Yes, I'm coming!"

"Good," he said, "I'll pick you up at seven Saturday evening."

She heard the phone click, sighed and went to answer the door. Beldin's secretary was a plain looking woman who smiled and said, "Hello, I'm Mary, Mr. Beldin's secretary."

She handed a typed page to Hedy. "These are the clothes Mr Beldin thinks you'll need here."

"You may add a Caftan to this." Hedy said. Mary dutifully jotted down the request.

The drive into Beverly Hills wasn't long enough for Hedy. She wanted to see more Palm Trees, more California casual homes, and breathe in the warm cotton candy air to reassure herself that she really was far away from Germany and Gunther. She turned to Mary, "Around here you'd never know there's a war going on, a blitzkrieg in Poland with the Nazi invasion.

Mary looked uncomfortable, "It could never happen here!"

Hedy wondered if all Americans were this naïve? The Chauffeur pulled up in front of Saks. Later when they had finished shopping, Mary reminded her they had to go to the studio for her English lesson and then meet in Beldin's office to sign contracts.

When Hedy walked into English class there were two other women there besides the teacher.

"Hi, I'm Tory Sontoug." A pretty blonde girl extended her hand and Hedy shook it.

"I'm Hedy."

The other woman smiled, "That sounds German; I'll bet Beldin changes it. I'm Mady Jackson, a confederate."

Hedy frowned, "What country is that?"

Mady laughed, "This one honey. It's the lone star state of Texas. We talk slower there but up here they're trying to make me a fast talker." She winked.

Hedy was a bit taken back by the buxom redhead. But

before Mady could react the spectacled English teacher tapped a ruler on her desk.

"Ladies, I shall endeavor to teach you English the way it should be spoken but that's not the Kings English. She turned to the blackboard behind her and began writing with chalk.

Mady whispered to Hedy, "We can talk later."

But Hedy was not anxious to make friends. Her experience with friends was that they take up too much time, were always curious, judgmental and jealous. For an hour Hedy listened to the teacher expound on elementary American English. Just about the time Hedy was getting mentally tired Mary walked in to take her to Beldin's office.

Beldin smiled as she walked in, "You look lovely, my dear, sit down."

He sat on the couch beside her and took her hand. "Here's the contract and you don't have to worry as I think of you like my own daughter. You're as safe as you were as a child."
"I was a child in Germany during the depression, not very safe!"

He patted her hand, "Well that's over. Lots of people have a lousy childhood, it's part of growing up."

Hedy didn't really hear him. She was thinking and said, "When I was 10 reality was so harsh that I pretended all the time. I went from pretending at home to pretending in school plays. When I was 15 a film director discovered me. I thought he would take me to a beautiful place." tears began to mist her eyes and her voice trailed off.

"Yes, yes, I know, he took advantage of you but I'm not." He handed her a pen. "Just sign here and we'll get you a divorce and a new life."

"A new life?"

"Yes, on the silver screen were all things are possible."

She was tired but it sounded wonderful so she signed.

He smiled, "You won't regret this."

She got up to leave and he gave her a goodbye kiss, not a fatherly one as he hugged her with his hand on her behind but it was too late now.

Chapter 3

HAPPY ENDINGS

In the 40's Hollywood
films always had
happy endings, Hah!
Anak

"**I** want the entire restaurant for two days my friend,"
Anak was talking to a Pakistani man. "You know the girls I want
and the ones to serve me."

"I understand," the man bowed slightly.

"The lady I'm bringing is exquisite. I need the evening to
be as unforgettable as she is! Send the bill to my office."

The man nodded, "It shall be done as you wish."

Anak drove back to his office and thought about Hedy.
Getting a woman like her was not an easy task. But his plan might
work. He loved a challenge in business and romance. Life was
hardly worth living without it.

Hedy prepared for her evening with Anak by relaxing
all day. She would wear the black, skin tight Sari gown trimmed
in gold with gold sandals that she bought when Mary took her
shopping. A studio makeup man had plucked her eyebrows to a
fine curving line and added mascara to her lashes. He showed her
how to outline her lips and put lipstick on to make them look full.
When Beldin had seen the results he smiled saying, "Perfect, she
looks like a spiritual nymphomaniac!"

The doorbell rang. It was Mary bringing an English
textbook. Hedy invited her in and as Mary was explaining how to
study the book Hedy was thinking how mousy-looking she was.
Maybe she could make a friend out of Mary by showing her how
to put makeup on.

"Here Mary," she pointed to her makeup table. "Sit down. I'll show you how to look beautiful in a few minutes."

Mary hesitated then sat down before the mirror and Hedy went about transforming her plain face into a striking one by using the makeup from the studio. Twenty minutes later Mary stared at herself in amazement. She thanked Hedy profusely and left.

Anak arrived early carrying a bottle of Champagne and an Orchid corsage with a tear drop one carat diamond on the end of a Platinum chain.

Hedy smiled, "How thoughtful of you." She put the diamond around her neck and left the corsage on a table.

"Shall we have a little Champagne before we leave? I heard you signed the contract with Beldin."

"News travels fast," she said surprised.

"Especially in this business," he grinned. "That shrewd old miser's whet the appetite of a few studio bosses with your nude swimming scene. Now he'll probably loan you out for more money than he's paying you."

"Oh, you saw my contact?"

"Not exactly, but that's the way of show business. He knows things about me that I wish he didn't and vice-versa." He opened the Champagne and she handed him two wine glasses. "Here's to you," he said and continued, "I've got Beldin worried as to what my plans are regarding another studio. Right now he's the most powerful man in Hollywood and he started with a Burlesque house."

She finished her Champagne and said, "I'm hungry."

Outside he opened the door to a sleek Cord roadster then he drove to the East Indian restaurant. When they walked in the Indian man was wearing a Turban. He bowed and greeted them.

Pungent incense hung heavily in the air and its aromatic vapor made Hedy slightly dizzy. They sat on purple satin pillows and rested their backs against walls draped with Oriental Rugs. Faint Eastern music played in the background. Hedy was startled by a young woman dressed in Harem pants but nude from the waist up. She served them drinks and aperitifs.

Hedy looked at Anak, "I suppose you imported a Harem just for tonight."

He smiled, "Complete with slave girls to wait on you." Hedy noticed how strong the drink was but continued to sip it.

Anak said, "In here are delights that most people only dream about but I lay them at your feet. Don't be afraid to relax and enjoy. You're safe with me."

Hedy raised an eyebrow, "That incense smells like Hashish."

"Ah, you know about Hash." He put his hand on the back of her neck. She leaned into his massage and slowly her tensions began to leave. She felt like she was standing on a high precipice where air was thin yet exhilarating. Her body began to tingle with that insatiable drive she knew too well but always struggled to hide.

From behind a curtained doorway, finger cymbal music floated through. Anak murmured in her ear, "The mystic occult is behind those curtains. Do you have the courage to challenge the God within yourself?"

Courage, that word was a challenge to her. She inhaled and her temples began to throb. Her whole body felt like it was possessed by an electric current that impelled her through the curtained doorway. Behind the curtain three young women and a man seemed to be absorbed in devotion. Some were on their knees

as if in prayer but when Hedy's eyes adjusted to the blue haze she realized their piety was a worship of each other. Two dark skinned girls surrounded her, one removed her clothes while the other took sandalwood scented oil and anointed her lips, her nipples, her navel and her clitoris in a hypnotizing ritual.

Hedy moaned feeling her passions rise as a young Adonis was behind her massaging her buttocks and another girl was in front massaging her breasts. She felt loved and desired as her excitement mounted until the pressure forced her to burst forth like uncorked Champagne bubbling through her body. Estrus frenzy captured her body and mind with a continuing need for more. She was briefly conscious of Anak's hands on her breasts then became acutely aware of him inside of her. He was wider and went deeper pushing her into a convulsive agony where she was sucking him in her womb, feverishly devouring all and demanding more.

He, the aggressor, became but a tool in the power of a skilled technician. Then miraculously every nerve in her body quivered and collapsed. During this eternity, Anak found himself held as if by a thousand tiny suction cups draining and demanding more. His control, the control he had long mastered, was exorcised.

Finally she released him and he sighed, "You're too much woman for just one man!"

Then he carried her to a heated pool and she was floating between three soft feminine bodies. All the goddesses were in this orange scented pool; Sappho, Bilitis, Mytilene and Hedy. Their hands caressed and probed her flesh into another shuddering sensuality, pulling breast to breast with a magnetic force that ended in a zealous consecration of pure Sapphism and all the while a camera's eye recorded it.

Evening drifted into morning before Hedy's eyes fluttered open to see Anak sitting crossleged on the floor and leaning back into the arms of a Golden Buddha. He was staring at her and smiling, "Are you satisfied yet, Hedy?"

Suddenly she became fearful. He had seen it all and he knew the truth. She was incensed. "What kind of man are you? You drugged me!"

He burst into laughter then became somber. "Oh Hedy, a Goddess takes responsibility for her actions. Deceive others if you must but never deceive yourself. You are a daughter of Aphrodite. Be proud of that!"

"Aphrodite? No, no I'm normal."

"Of course you're normal," he became angry. "You simply have a greater capacity to abandon yourself and enjoy life than most women do. The challenge is can you develop the strength to love without destroying yourself or others?"

She frowned confused. "Take me home!" Her fears were not appeased.

Chapter 4

LUCK, TIMING AND TALENT

"Show business
success is luck, timing and talent, in that order!
Hedy Lamarr

As Hedy and Anak entered her apartment lobby, Mady sashayed up to them wearing a skin tight black, low cut jersey dress. There was no doubt that sex smouldered in her eyes. "Hi, ya'll," she smiled. "It looks like all us girls are in the same building."

Hedy nodded but felt suddenly insecure and just kept walking to the elevator. Anak followed but eyed Mady's swinging hips as she disappeared out the door. He grinned, "What kind of place does Beldin have here?"

"A Nunnery!" Hedy said flatly closing the elevator door in his face.

Anak stared at the mute panels then sighed and walked back to his car. Damn, he thought, she has the potential to be a fantastic woman, his kind of woman, but does she have the basic honesty? Without that she could never be trusted.

Hedy collapsed on her bed feeling an aching soreness in muscles she never knew she had. Why was she cursed so, to be the tool of selfish men and their perverted lusts? Then her thoughts drifted to the exquisite ecstasy she had felt as both sexes desired her. But she stopped those thoughts and convinced herself she had been taken advantage of again. She longed to return to the innocence of her childhood before that terrible Director used her talent for his pornographic film and before Gunther. She shivered; well someday she would get revenge.

The next morning Beldin phoned, "Hedy, before you go to class today, stop by my office. I have a script I want you to read."

"Alright," she said and heard the doorbell ring. In front of her door sat a tall basket of flowers with a stuffed Panda in the middle. Attached to the Panda's neck was a card that said, "Ich liebe dich, Anak."

"I love you?" she said aloud. Ha, what does he know of love? She grabbed the basket and shut the door.

The phone rang. "Hello Princess."

She sighed, "Your flowers just arrived."

"Good, I hope you like them. Silver roses are my favorite. I'll give you a more expensive gift when I return from Greece. I'm leaving in 2 hours but I want you to know that I'm looking forward to our next dinner."

"Never!"

"Never say never; one doesn't know what surprises life has in store for us."

She sighed and hung up.

When Hedy arrived at Beldin's office he welcomed her with a hug. "Sit down, my dear. I want to tell you about this script."

She sat on a leather couch opposite his desk and he handed her the script. "Paradon Pictures needs a beautiful, foreign actress to play opposite Charles Ballad. Ballad is the leading man and I managed, with my connections and your beauty, to get you the part opposite him."

"My God," she thought, that's what Anak said he'd do, loan her out to another studio for her first film.

He took a cigar out of his humidor and rolled it over his tongue then pointed it at her, "However, there is one nude scene which will be fine for the foreign market but it's not the Beldin studio image so I told them to photograph you from the back.

Now why don't we celebrate? I'll take you to the Mocambo tonight."

"But, what if I don't like the script?" she asked.

He laughed, "Let me worry about your career. Believe me I want you to be a success. You just look beautiful and they'll keepwanting more."

Alright, she thought. I'll play his game but not exactly according to his rules. "Alright, then I'd better stay home and read this script tonight."

He frowned. Didn't she know that his invitation was compulsory? Well, maybe a little of Brick Kone at Paradon would educate her then he could show compassion.

She was staring at an invitation on his desk. An ink drawing of a woman's torso from the waist to the upper thighs with a feminine face staring hauntingly from the pubic area.

The large eyes were below the navel and the lips were the clitoris should be.

"Oh," he said, "isn't that the damndest invitation you've ever seen. It's for an Art Gallery opening. A lot of press and celebrities will be there so I think you should go and have your picture taken with the owner. He's supposed to be some kind of British royalty, you know like that guy Romanoff. He's supposed to be Russian royalty.

She picked up the invitation. "Provocative."

"Yes, take it with you. The address and time are on the back. I already had my secretary RSVP for us."

As soon as she left, Beldin picked up his private line and called Brick Kone. "Kone, Beldin here, about your Ivory Coast script. I had a tough time convincing Hedy she should do it. She wants $700 a week."

"What?" Kone bellowed, "I'll import a damn Sverdlovsh whore before I pay a penny over $500!"

"Well, lucky for you she likes the script. I think it's pretty good except it lacks sex." He puffed smoke circles in the air.

"Lacks sex! We've got the Zulu warrior raping the Missionary's wife!"

"Yes but you need esthetic sex. Give it class not ass. Have Hedy do a brief nude scene but film it from the back."
There was a moment of silence then Kone said, "You mean show her ass. You sonofabitch, you can't get away with that at your convent so you want me to give your girl sensationalism so when she comes back she's automatic box office!"

"Why the hell do you care?" Beldin chomped down on the cigar spitting it over the phone as he talked. "You're not going to get the Good Housekeeping seal of approval on this one. I hear you're in the red ink right now so why can't you capitalize on a sure thing? Think about what a sensation her German film was."

Kone hated Beldin but all he said was, "OK." Then hung up and turned to Anak smiling. "We got the Bitch! Your investment is secure!"

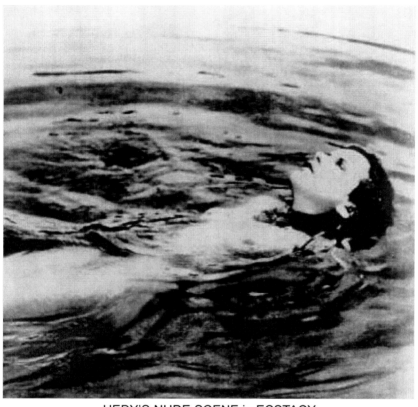

HEDY'S NUDE SCENE in ECSTACY

Chapter 5

BITCH GODDESS

"That Bitch Goddess, Success!"

It was a hot, smoggy day in Hollywood. Activity on the Paradon lot was frenzied with tempers flaring at the slightest provocation. Hedy sweltered inside the giant soundstage as the air conditioner was losing the battle with the steel scrims and arclights.

A makeup man tried to keep the shine off her face while a director in riding pants yelled through his megaphone, "Set up the long focus lens and loop the dialogue later."

He walked over to Hedy, "Now, Hedy, all you do is step from the outdoor shower naked with your back to the camera, grab a towel and run into the hut."

She nodded as the makeup man applied glycerin to her lips. Most of her American film debut consisted of sultry stares, moist lips and inhaling so her breasts appeared to burst the buttons on her Khaki blouse. She knew that and asked, "Don't I have any dialogue here?"

Jack Byer smiled, "You're doing fine. You say more with silence than most actresses do with talking." Jack was a handsome man of medium build who started as an actor but soon went into directing.

"But if you're shooting me from the waist up, why can't I wear panties?"

"Because you move differently when you're totally nude. Don't worry; the audience won't see anything, they'll just think they do." He glanced around. "Where's the set decorator? Where's Nord Slaven?"

"Here Handsome," A blond, young man walked up putting his hand on Jack's shoulder in an intimate way. "What do you need?"

"I need that Palm tree moved to the right so the crew can't see her ass but the camera can." Then he motioned to both cameras as a pair of clapsticks identified the scene. He picked up his megaphone and yelled, "Lights," Keylights shot up in a burst of artificial sunlight. "Camera, action."

A boom silently twisted a microphone over the set and Hedy did the scene. As soon as she heard "Cut!" She dashed into her dressing room to soak in a cool bath. She didn't hear the knock on her door but even with her eyes closed she sensed someone standing next to the tub. She opened her eyes, "Anak!"

He smiled kneeling next to her. "I thought you'd like to know you're working for me now. I bought this studio today."

She frowned.

"You should be thrilled. I'm a lot easier to work for than Brick Kone. I thought we might celebrate tonight."

"You're joking," she said astonished.

He chuckled, "I've got a lot to tell you. While I was in Europe I met with your husband. He's a determined, angry man."

She was immediately apprehensive, how much did Anak know? Quickly she said, "Beldin arranged a Mexican divorce for me."

"Who knows if it's legal?" Anak shrugged.

"It's legal enough for me!"

His eyes lingered on her bare breasts under the water, he sighed, "Tonight we should be together."

"I just want to go to bed," she said tired.

"Me too," he grinned.

"Alone!"

"Ah Hedy, you're breaking my heart."

"What heart?"

"That's not nice. Think how I saved you from that ugly, fat Kone. I bought the arch villain out of your life."

Hedy's hand was resting on the edge of the tub. Her long fingernails painted a deep red. Anak lifted one of her fingers, "You won't have to sink these talons into Kone but you may need them for Beldin."

Someone knocked on her door, "Miss, we need you for more outdoor scenes in ten minutes."

"Thank you," she yelled back. "Well Anak, if you want to make money on this picture you'd better leave so I can go back to work."

"You said the magic word but there's an opening tomorrow night at the Centaur Art Gallery with big press coverage. It would be good publicity for you."

"Yes, I know, Beldin and his wife are taking me."

"No, I'm taking you. When I told Beldin I bought Paradon he said I could take you. I'll pick you up at seven sharp." He kissed the top of her breasts and left.

Chapter 6

BETTER THRU MUSIC

Often a movie is told better thru music.

The roving spotlight nearly blinded Hedy as she emerged from the studio limousine with Anak. He wore white tie and tails. His Satin lapels matched her white Satin Jean Harlow gown. They walked through the pillared entrance of the Centaur Gallery as photographers jostled each other trying to get as many photos as possible in the two minutes it took Hedy and Anak to disappear into the throng of art critics, celebrities and royalty.

Ubiquitous security guards hovered in the background. The first thing Hedy noticed upon entering was the five foot metal family crest hanging on the wall with the name Bolton inscribed underneath white doves, blue plumes and silver shields.

Hedy was instantly surrounded by a bevy of people but the moment Sir Philip Bolton came into view their eyes captured each other. He walked directly to her, bowed slightly, kissed her hand and for a brief moment they became a unit apart from the laughter and conversation of the current Hollywood set.

"Welcome to my gallery," he smiled at her.

Beldin offered introductions, "Sir Philip Bolton this is my new star, Hedy"

Anak was immediately aware of the imperceptible electricity that passed between Hedy and Philip.

"I'm delighted to have you at the opening of my new gallery, "Philip said. "May I show you some of the Countess D'Orsenas priceless collection of Cezannes?"

Hedy smiled thinking how handsome Philip was with his thick black hair and his lean tan face. He looked like a storybook

Prince. She put her hand on his extended arm and they walked to the opposite end of the Gallery.

Anak looked at Beldin and sighed, "We're in trouble, my friend. I think she's going to be taken in by this royal ruse." Beldin groaned.

An older gentlemen stepped out of the crowd and approached Hedy. Philip said, "Oh, I'd like you to meet my father, Sir Peter Bolton."

Peter Bolton kissed Hedy's hand, "My pleasure."

Hedy smiled, "I was just admiring your son's excellent taste in paintings."

"And I admire his excellent taste in women," Peter said. "But did he show you the 1620 Rubens? Rubens' technique of glazing with translucent films of color give his paintings a luminous quality."

"I was getting to that," Philip said quickly. Hedy sensed a subtle competition between father and son.

An elegantly attired woman in her late 60's approached them, "Peter, I've been looking for you. Baron and Baroness Ridloff are here."

"Ah," Peter bowed slightly to Hedy. "Please excuse me, business calls."

"That was Countess D'Orsena," Philip offered, "She's jealous of beautiful women like you."

Hedy nodded, "If I looked like her I'd feel the same."

They both laughed and Philip continued showing her paintings. "Now this Manet is Circa 1879. Manet was one of the Prima Painters. This is "Prometheus Bound." He pointed to a large painting of a muscular male body entwined in chains that he is trying to break out of. Hedy found the painting interesting but was

more intrigued by Philip's spellbound expression as he gazed at it.

"Philip," she said softly then louder, "Philip?"

"Oh," he snapped out of his reverie as his father returned.

Peter smiled at Hedy, "You are as exquisite in person as you are on screen. May I have the pleasure of your company at Charlie Chaplins' dinner party tomorrow night?"

Hedy smiled demurely, thinking he must have seen her European film. "Oh, thank you for the invitation but your son asked me out for tomorrow night."

The elder Bolton looked as surprised as Philip did but slapped him on the back saying, "Good for you, son!" Then he turned back to her saying, "Hedy, if any woman can bring him out of his shell you can." He walked away.

Hedy gave Philip a wide-eyed look, "I hope you don't mind. I didn't want to hurt your father's feelings."

"Oh, no of course not," Philip hesitated, "as a matter of fact I was going to ask you out. Is tomorrow evening open for dinner?"

"Yes, but I like to eat early. Could you pick me up by six?"

Philip nodded just as Jack Byer walked up with Nord Slaven, "Hedy, I thought you'd be here." He turned to Philip and noticed the family crest on his jacket. "You must be Sir Philip Bolton. I just met your father. You have a fabulous gallery."

Hedy said, "Jack is my Director and Nord is the set decorator."

Nord smiled, "And Hedy is going to be the next big Hollywood star but Bette Davis is over there so don't say it too loud."

"Thank you, Nord," Hedy smiled. Nord had a delicately handsome face framed by blond hair. With his perfect nose he could have been Hedy's brother.

"Nord is an excellent artist," Jack was saying to Peter. "He drew some fantastic costume sketches of Hedy. Why don't you both come to our house this weekend and see for yourself."

Philip hesitated, "Maybe, could I let Hedy know tomorrow?"

"Sure," Jack said looking over at a couple who just walked in. "Oh, there's Charles Ballad and his wife, Jacey." He waved and Jacey broke away from a group and walked over to them.

She smiled, "Hello Hedy, I saw your films rushes and I must say you brought out the best in Charles' performance. I think you're going to have a hit movie."

"Thank you, Jacey," Hedy smiled accepting a glass of Champagne as a waiter passed a tray around and piano music played softly in the background. "Who's playing the piano?" Hedy asked.

"That's George Andrews. He plays background music for parties and films," Philip answered.

"That's nice. I play a little myself, could you introduce me?"

"Sure, excuse us," Philip escorted her over to the piano. During the party Anak had been circulating but he never took his eyes off Hedy for more than a few minutes.

But now Tita Harris had him cornered. She was wearing black and white and her constant expression of bored disdain. "Well Anak, I can hardly wait to write about all this titillating social intercourse in my next column."

Anak nodded, "May I get you a drink?"

"No, darling, I don't drink at these parties. I like to go home aggravated. I write better that way."

They watched Hedy sit down next to George at the piano and in a few moments they played a duet together of "Symphony in Blue."

"Ah," Tita said, "so she has many talents even with her clothes on. I see that Sir Philip seems quite taken with her."

Anak gave Tita a funny look, "I can only hope his intentions are honorable."

Tita laughed, "You must be joking. In this town nobody's intentions are honorable!"

Hedy loved playing the piano with George and asked, "Could you play background music for my next movie?"

"Yes, if I'm hired."

"I'll speak to Beldin about hiring you."

"Thank you, and may I say you play very well."

"I had some lessons as a child. I enjoy music very much, it's like a hobby for me. Maybe we could compose some new tunes together?"

He nodded, "Just let me know when."

HEDY ALWAYS MAKES AN ENTRANCE

Chapter 7

HITLER POSTPONES BRITAIN
September 1940 Hitler postpones invading Britain.
Hedy postpones nothing.

That weekend Jack Byer reminded Hedy of his invitation. Hedy said she would speak to Philip about it but in truth he had not called her after their dinner evening. So she decided to call him. He apologized for not calling saying how busy he was. She sensed that he wasn't that interested in her but when he accepted going to Jack's house on Saturday night she pushed that thought out of her head.

They arrived at Jack and Nord's Hollywood Hills home at 6 pm on an exceptionally warm evening for April. Hedy wore a simple cotton dress but Philip wore a navy blue linen suit with his family crest on the pocket.

When Nord opened the door he appeared naked except for a small red apron around his waist. "Welcome," he smiled holding up a wooden spoon. Come into the kitchen. Jack's in the swimming pool." He turned and they saw his bathing suit was just an athletic supporter.

"Oh," Jack said, "I should have told you to bring your swim suits. Well, if you feel like swimming in the nude that's fine with us."

He opened a bottle of red wine and poured 3 glasses. "You'll love this Merlot, it's good for your digestion and I've made a wonderful steak dinner." He handed Hedy a glass and she noticed how smooth his body looked as if it had been shaved and rubbed with oil. "Come we'll go into the living room and I'll tell Jack you're here."

The first thing Hedy noticed was a large canvass bursting with color that hung over the fireplace. It looked like a volcano exploding molten lava. Nord walked back in and saw them looking at the picture. "I call that one Orgasm!" he laughed. On an opposite wall hung another large canvas that looked like planets bursting into space. "And that one I call Birth."

"I like abstracts," Philip said.

"Yes," Hedy said, "I paint like that sometimes."

"Come see my other paintings, they're in the bedroom." Over the king size bed hung a large portrait of a beautiful woman.

Hedy gasped, "That looks like me!"

"I know," Nord smiled opening a photo album laying on his dresser. "These were taken at a costume party I attended last year." There were five poses of a beautifully gowned and made up Nord. He placed his hand on his hip and said, "I hope you like my style. I'm really versatile!" He laughed but Hedy and Philip didn't."

Jack walked into the room wearing a towel around his waist. "Oh Nord, you're not shocking these good people are you?"

Nord smirked, "I don't think Hedy is easily shocked. We're really sisters under the skin. Right, Hedy?"

She half smiled, "You do my makeup better than I do."

Jack felt the tension and changed the subject. "I just heard a news broadcast and Roosevelt is denying we'll join the European war."

"Bullshit," Nord said flatly. "I think we're headed straight for war."

Hedy sighed, "I think you're right. I know your president is selling airplanes to your allies."

Jack nodded, "We would be smart to ask Hedy what's going on since she recently came from Europe."

"I can tell you that the Nazi's are building planes in
Austrian plants and my ex-husband is furnishing the parts."

Philip said, "I heard the British are dropping boots in
Germany with leaflets that say, "For your Fuhrer. He'll need them
to run away from us."

Everyone laughed except Hedy, "He may use them to kick
the hell out of the British!"

Nord sighed, "Well, I'm not worried. They won't draft
me!"

Jack laughed, "I'm drafting you into the kitchen. Get the
dinner out."

"And you can help serve," Nord said over his shoulder.

Philip and Hedy walked into the dining room. During
the meal Nord said, "Well Hedy, soon you'll be rich and famous
and if you follow the script the next thing you do is marry Prince
Charming and live happily ever after; as if anyone really believes
that crap!"

Jack sighed, "Pay no attention to Mr. Jaded."

"Come on, Jack, you don't believe that love forever stuff
either. Love is a state of mind. A state that people move in and out
of. Don't you agree, Philip?"

"I, ah, really don't feel qualified to answer since I've never
been in love."

"Hmmm," Nord stared at Philip, "interesting since you
must be in your thirties. Do you believe in reincarnation? I know I
was a woman in my last life because I have a woman's soul. Philip
I feel we were lovers the last time around!"

Jack nearly choked on his wine and Philip blushed but
Nord continued, "Don't be upset if you find out you're like the
rest of us, just an old-fashioned Bisexual."

Hedy looked surprised then stood up, "Well gentlemen, this has been an interesting evening but I have an early call tomorrow so we must leave now."

"What about dessert?" Nord said, "I fixed my special Mouse Goose."

"I'm on a diet," Hedy answered as Philip followed her to the door.

Jack rushed up behind them, "I hope Nord didn't offend you. He's just a very honest person with his opinions."

Hedy answered, "No, Nord is right I'm not easily offended but I do have to get up early so I'll see you on the set tomorrow."

After they left Jack turned to Nord. "I know you were curious about Hedy cause she resembles you but you could have been more subtle. You may have scared Philip and his art gallery away."

Nord smiled, "Don't bet on it. Let's have dessert."

As Hedy and Philip drove back to her apartment she said, "Tell me about your royal family."

He smiled, "I don't know about how royal we are but Dad says so. Mother died five years ago. I'm his only child who hasn't had much time to do anything except work."

"Well, I think having a title is a great gift to pass on to your children."

"If I ever have any; since I turned 38 last summer Dad has given up on me marrying."

"Ridiculous, you're in the prime of your life."

He shook his head. "My life is dull compared to you. Having an acting career probably means you're not interested in being a wife and mother and all those normal things."

Hedy tensed up at the word normal. "What do you mean,

that a woman who isn't a wife and mother can't be normal?"

"Oh no, I didn't mean that. I guess I meant to say average. You're certainly not average."

He pulled up in front of her building and opened the car door for her.

"Would you like to come in for a nightcap?" she asked.

"Oh, thank you but I'll have to take a rain check on that as I have an early call tomorrow also."

Hedy wasn't easily discouraged so at her door she said, "Perhaps you could come to dinner next Saturday evening. I make an excellent Beef Stroganoff."

"Thank you, alright, next Saturday at six?"

"Good," she said and kissed his cheek.

Philip did come to dinner but in spite of her low cut hostess gown and her Stroganoff she couldn't seem to break through his staid British attitude. It would be difficult for most people to have a formal dinner for two but Philip made it easy. At the evenings end he kissed her goodnight and promised to call.

While she was cleaning up dishes she thought about Philip and her future. He was handsome and intelligent and she was attracted by his aloofness. She decided he would be her next project after she finished the film. He could help her keep Anak, Beldin, and Gunther at a distance.

For the next month she concentrated on finishing the film and only talked to Philip on the phone. When the film was completed Beldin arranged a big Hollywood premiere and also arranged for a young actor at his studio to escort Hedy. She would have preferred Philip but Beldin convinced her that the publicity would be better with another actor.

On the day of the premiere Hedy's Mexican divorce

came through. Now she had two things to celebrate. She spent
the afternoon at the studio beauty parlor being pampered by
a hairdresser and makeup artist. She sipped warm water with
whiskey to relax. That night at her door she greeted her date
wearing a low cut black satin gown with a red sash and her date
looked impressed.

"Hello, I'm Gentry Sloan," he smiled and handed her a
bottle of Champagne. "I thought you might like a drink in the
limousine."

"How thoughtful," she smiled looking at this handsome,
blond, six foot Viking type. She was already relaxed from the
whiskey and water.

He escorted her to the limousine. "I'm celebrating a film I
just finished too. I play a Canadian Mountie."

"And you look like one," she smiled.

In the chauffeured limousine he opened the Champagne
and poured two glasses. "To our success."

Hedy sipped the drink and felt a little drunk from her
afternoon imbibing. The streets were mobbed as they approached
the theatre and people strained to get a glimpse of them as the
Limo slowly glided to the theatre entrance. Flashbulbs exploded
as they alighted amidst screaming fans that made Hedy hesitant to
greet her public.

"Don't be frightened," Gentry reassured her. "All that
screaming means money to us!"
Together they posed and signed autographs while cameramen
shouted for them to hug and kiss. Hedy smiled and waved as they
walked up the red carpet to the lobby. Screaming youngsters
charged in trying to grab a 5 foot poster of Hedy. Two policemen
hustled them away but not before they broke off the posters head.

Hedy shuddered at that. Then an usher lead them to their seats.

When the screen illuminated Hedy was seen walking towards the camera while titles appeared superimposed.; a new presentation that brought applause. Then the film began. Half way through Hedy's semi-nude scene flashed on the screen. For a brief moment she was seen nude then grabbing a towel and stepping from a shower. The audience gasped.

"Oh, they're hissing me," Hedy groaned grabbing Gentry's arm. "Come with me." Before he could answer they were half way up the aisle and emerging into the lobby.

"What's the matter?" he asked bewildered.

"That stupid cameraman got the wrong angle. I can't watch myself."

He sighed, "Well we can't leave."

She walked to a side exit and peered out. Several photographers milled around and half the crowd was still there. Two photographers walked into the lobby and she pulled his arm. "I don't want them to see me." She saw a door marked, 'Keep Out' and yanked him in.

He kicked a mop in the dark and it hit his head. "This is a broom closet!"

"Shhh," she whispered and they stood motionless amid brooms, buckets and cleaning utensils. Then he pressed against her and she didn't move. Silent communication began as Hedy's emotions again enveloped her with an insatiable need to be loved. She moaned as he rubbed his open palm over her breast and the nipple stood out under the thin satin material. She felt his swelling penis as he lifted her gown and in a moment he was pressing himself inside her but in another moment he climaxed.

"You selfish bastard!" she swore at him.

"I'm sorry. I guess I'm nervous."

She grabbed his hair and pushed his head down.

"No," he said.

Hedy was incensed. "Would you rather I tell the reporters you tried to rape me!"

He groaned and dropped to his knees. A few minutes passed before the closet door opened and a maid threw a mop inside then slammed the door. The handle hit Gentry's head.

"Ouch," he dropped the hem of her gown and the door slowly opened again. A bewildered black woman stared at them. Hedy quickly regained her composure and swept past the startled woman.

"Pardon me," Gentry said stumbling after her while wiping his mouth with a handkerchief. He followed Hedy back down the aisle and into their seats just as the last scene faded out and the lights came up. "Good timing," he sighed.

Back in the lobby Beldin was standing with a group of people but as soon as he saw Hedy he beckoned to her. "My dear, you were magnificent!" he kissed her cheek.

"I'm having a little celebration at my house as soon as you get there. Your driver knows the way."

"Great," Gentry said taking Hedy's arm and escorting her outside to the screaming crowd.

"Why do they scream so much?" she asked him.

Gentry laughed, "They scream to relieve tension. They don't know about your broom closet!"

Chapter 8

ALONE or MEAN MORTAL

The man who lives for self alone, lives for the meanest
mortal known.

In America, Hedy's film caused quite a controversy
and she became an overnight sensation according to all the fan
magazines. Beldin quickly put her to work in one of his films.
That didn't give her much time to socialize but she did manage a
few dates with Philip. Anak called every week but she would not
see him. There was no future with a married man like Anak.

Halfway through her new film Beldin summoned her to
his office. It was late afternoon and Hedy thought she detected the
odor of Whiskey when she walked in.

"Hedy," his tone was conciliatory, "you've been working
so hard I want to show my appreciation. I'll take you out to an
early dinner and we can talk."

"I can't, I'm supposed to be back on the set in 20 minutes.
But if you really want to show your appreciation then double my
salary."

He coughed, "Hedy, be reasonable. I've been like a father
to you."

"That's not saying much. My father never did a thing for
me."

Beldin walked around his desk and took her hand, "I'm
sincerely interested in your welfare. If you listen to me your
success is assured."

He pulled her close but she stiffened against his grip, "Mr.
Beldin, Please!"

He pressed against her. "I can really help you."

Suddenly she hated this fat, ugly man and at this point she knew he needed her more than she needed him. With her free hand she pushed him back, "You despicable despot!" Then she stalked out of the room.

He stared stunned at the door as he was not used to rejection with such high class words. He wondered how she managed to make him think she would be cooperative. Perhaps she was a better actress than he thought. Well, he would have to keep a closer eye on this valuable property.

He sat back down at his desk and snapped on the intercom. "Mary, I want a full report on Hedy. Who she's seeing and where she's going."

But he need not have bothered because three days later she announced her engagement to Philip. Beldin was furious so he called Anak.

When Anak heard Beldin's voice he laughed, "I thought you'd be calling when I saw her engagement headlines."

Beldin groaned, "What are we going to do? How can we keep her from marrying that royal phoney?"

"I'm surprised at you, Beldin, didn't you investigate her past?"

"No, but I suppose you did."

"Yes, and I found some interesting facts. She was a precocious child. Her marriage at 16 was arranged by her parents but her husband was sadistically abusive. Of course that perverted her sexuality. As you know she's a woman of extraordinary beauty and talent but sadly her past may have scarred her for life."

"Yes, yes, but how can we stop this stupid marriage?"

There was a pause then Anak said, "Maybe Dorita can

help. She's my new studio masseuse, pretty and has talented hands."

"Are you saying this woman's a lesbian?"

"She's whatever you want her to be as long as you pay her."

"But Hedy's normal, we don't want to change her."

"What's normal? We won't change her, we'll just divert her until she gets over this marriage idea."

"Do you think it'll work," Beldin was apprehensive.

"Listen, my friend, according to Indian culture it makes a good woman better."

"Ok, but if this backfires I hold you responsible." Beldin hung up and sighed, "What I don't do for this studio."

That evening Anak called Hedy, "Congratulations, your pictures a big success and they want your bosom impression in cement at Grauman's." He laughed but she didn't. He continued, "So you're going to get married?"

"Yes, but I've just come home from the studio and I'm very tired."

"Oh, let me help," Anak said, "I'll send over my studio masseuse and you'll be good as new in the morning."

"Well," Hedy softened, "how nice of you."

"I'll send her in an hour. Why don't you take a relaxing bath and by the time you're finished she'll be there." He hung up and called Dorita, telling her exactly what he wanted her to do.

Hedy relaxed in a hot bath for 20 minutes then went to lie down when the phone rang, "Hi Hedy, it's Nord, congratulations on your engagement to Philip. I was thinking maybe you could arrnge an art exhibit for me and I'll give you a 20% commission."

"Hmmm," Hedy thought she wouldn't mind having an exhibit of her own art. But she said, "I'll see what I can do."

"Great. You know since your sexy jungle picture is such a hit, I hear Howard Hughes is planning on pushing the Censors Code to the limit with a big breasted actress for a film called, "The Outlaw.""

Hedy bristled, "I'm not worried. I have more talent than just breasts."

"Oh, of course you do darling."

As soon as she hung up Philip called, "Hedy, you wouldn't believe what a sensation our engagement has caused. Today I sold out half my gallery. They're buying like they're collecting souvenirs."

"You see, Philip, besides the fact that we love each other our engagement will be beneficial for your business also."

The doorbell rang. "Oh, I think that's my masseuse. I'll talk to you tomorrow."

The masseuse was a beautiful, dark haired woman in her twenties. She smiled displaying even white teeth. "Hello, I'm Dorita."

"Yes, come in." Hedy led her to the bedroom. Dorita set up her portable table and spread a towel over it. She laid another towel over Hedy's nude body and began the massage. The exotic oils she used help to relax Hedy even more and she was almost asleep when she felt Dorita's hand rubbing the soft lips of her clitoris and then her mouth softly sucking a nipple. Hedy's breath caught in her throat and she moaned as her whole body became electrified with exquisite pleasure. Her body suddenly had a mind of its own and she was screaming towards a shuddering climax. When she opened her eyes, Dorita was smiling. "I hope you're more relaxed now. Mr. Stanislaus told me to ask how often you want a massage?"

Hedy thought a moment then said, "I'll call you. Leave

your number."

Then she felt Doritas arms lifting and helping her into bed. She fell asleep exhausted and Dorita quietly left.

Chapter 9

PLEASURE

Pleasure is nothing more than the intermission of pain.

A month later Hedy had finished her picture and set a date for her wedding a week later. It would be aboard the yacht of Philip's friend Baron Ridloff. Hedy called the press personally and reporters with photographers swarmed over the yacht like bees to honey. They drank, conversed with celebrities and socialites then took pictures of the wedding.

After the ceremony a reporter said, "Miss, oh, excuse me, I should call you Lady Bolton now. Is it true you've refused to make another picture until you get a raise?"

Hedy was annoyed, "Where did you hear that gossip?" Tita Harris turned around from a group saying, "Did I hear the word gossip? That's what I'm here for."

Hedy said, "Perhaps you two should exchange gossip together. You know more than I do."

The Baron overheard the conversation and sensed it needed interrupting so he did his imitation of W.C. Fields and said loudly, "Where are my fancy food fumblers. Let us partake of the repasse."

A deck hand passed a tray of finger sandwiches but Tita wasn't distracted, "Hedy, did you see what Winchell said about your performance? He said he's never witnessed a more daring diversion."

Philip laughed, "That's quite a comment from someone who lives in New York."

Tita asked Hedy, "Are you going to give up your career for marriage?"

Philip answered, "I wouldn't ask my wife to give up anything. Marriage should add to a woman's life not take away." The Baron held up two glasses, "Listen Hedy, if you two don't start drinking you won't be able to communicate with the rest of us."

Hedy laughed and broke the tension. She and Philip toasted their marriage and the reporter headed for the bar and asked the young bartender, "Do you work for the Baron?"

"Nope. I'm hired for this cruise only. I'll be going back to college next semester."

"How much do you make at this job?"

"Ten bucks a day plus room and board for the cruise."

The reporter said, "I'll pay you twice that. All you have to do is take a few pictures for me and if they're informal enough you get a bonus." He winked and pulled out a small camera and his card giving both to the bartender. The boy put it under the bar.

Philip's father slapped Philip on the back, "Congratulations my boy. I was beginning to think you'd never get married."

"Oh Dad," Philip looked surprised. "I'm glad you made it back from London."

Then a bell sounded and the Baron asked that everyone leave except the wedding party. Press and guests staggered down the gangplank. Peter waved goodbye and the Captain weighed anchor. The yachts motors churned water to a bubbling foam as the hundred foot yacht pushed out to open sea and Catalina Island.

Philip put his arm around Hedy, "It's not the Queen Mary but it'll have to do for our honeymoon."

"Oh Philip, it's a lovely yacht. Besides I heard the Queen is being used for secret war missions."

"Let's be optimistic," he hugged her. "Dad says both central trade and America are backing the underground to overthrow Hitler."

The Baroness interrupted, "My compliments to both of you for the way you handled the press."

Philip smiled, "Do you think your bartender could make me an English Pimms Cup?"

"If he can't, I will," she said as they walked to the bar then whispered, "I do think it's courageous of you to marry an actress. It's quite difficult to live in the public eye all the time."

"I'll brace myself with Pimms," he smiled.

She laughed and went back to Hedy. They settled into deck chairs as the yacht's rocking motion lulled everyone into silent soliloquies. The Baron sipped his drink and envied Philip his beautiful new wife. The Baroness sipped hers and envied Hedy her handsome new husband. Philip sipped his and wondered if he really could adjust to life with Hedy. He knew his father was happy about it.

It took two hours to sail from Long Beach to Catalina and 20 minutes to maneuver the huge vessel into a berth alongside Avalon dock. Then their intimate group walked down the gangplank and over cobblestone streets to the burning torches in front of Blackbeards Cave Restaurant.

"This is delightful," The Baroness enthused as they were seated by waiters in Pirate's costumes.

"Grog for everyone," the Baron ordered.

"As if we haven't had enough," the Baroness laughed as large pewter mugs filled with liquid ambrosia were placed before them. By the time steaks arrived the Baron was telling ribald stories and the Baroness was laughing the loudest. Hedy

felt mellow but didn't consider herself drunk. Philip, however, appeared numb with a frozen smile.

After their bill was paid their small group stumbled into the blue midnight and weaved their way back to the ship. The two couples bid each other goodnight and went to their respective quarters. Philip laid down on the bunk and passed out. Hedy slowly undressed him and couldn't help noticing that in his present condition his manhood wasn't impressive. She sighed, undressed and laid down beside him. Some wedding night, she thought, as she listened to the water slosh against the hull. Certainly not like the one she had with Gunther. When she awoke at noon the next day Philip was already dressed and drinking a Bloody Mary on deck.

"Good afternoon, darling," he kissed her cheek. "If you have a hangover try one of these."

"I'll have plain water," Hedy said looking at a group of people on the island who seemed to be shouting and running about. "Looks like the natives are restless."

The Baroness came on deck complaining, "Too much noise out there for my head this morning." She ordered an aspirin with water from the steward.

The Baron observed the crowd as he came up from below, "Perhaps they're celebrating the month of December and Christmas coming."

Philip suggested, "Why don't we go on shore for a little walk. We might all feel better on land."

They walked down the main street and someone yelled, "We're at War!"

Hedy gasped, "It's happened."

Philip motioned, "Let's go into that corner pub, they may have a radio on."

The moment they walked in the door they saw a group huddled around a radio that was blaring, "Japanese planes in overwhelming force have attacked the American Naval Base at Pearl Harbor in the Hawaiian Islands. Heavy casualties to the American pacific fleet have been reported; No word from the White House yet."

They all slumped into chairs around a table and the Baron said, "I'm not surprised. This has been coming for a long time. That's why the Baroness and I sold our property in Europe and bought the Yacht to sail to America."

"You knew it was coming?" Philip asked.

"Well not for sure, but anyone who heard what the German Socialists were doing could guess the outcome. I heard a Berlin broadcast one night where the man said war was a blessing of God; The eternal fountain from which new generations of men are born. Hitler wants to kill anyone who's not Aryan and take over the world. Bit of a megalomaniac. But to Hell with Hitler! The most sensible thing to do is enjoy today like there's no tomorrow."

Hedy nodded, "There may be no tomorrow. My ex-husband owns a Munitions Factory and when he had meetings with Hitler I overheard him say he didn't want any Jew, Slav, Homosexual, Cripple or Retard in Germany."

Philip laughed, "Then he'll have to get rid of himself!"

The Baron called over a waiter, "My good fellow, this shattering news calls for a round of drinks for everyone here. Set it up for my friends and yours."

The waiter nodded and soon everyone had a new drink but still the gloomy quiet persisted. The Baroness was first to dispel the impending doom feeling. Straightening her back she said loudly, "It's time to play that music box."

In a few seconds a light-hearted "Roll Out the Barrels, let's have a barrel of fun," boomed from the Juke Box and everyone started singing. Then some serious drinking followed. The Baron glanced at the door and was surprised to see his crew enter.

The young Bartender came up to him, "Sir, have you heard the war news?"

"We heard, but who gave you permission to leave the ship?"

"I, ah, I," the boy stuttered.

The Baroness interrupted, "Oh let them stay. They'll probably be going to war soon anyway."

"Alright, line the crew up for a drink at the bar," the Baron ordered.

Soon people started dancing and a young muscular man pressed up against Hedy when she went to the Juke Box and whispered in her ear, "Hello beautiful, how about a dance?"

Philip walked up and pushed the man back, "What do you think you're doing?"

"The best I can, Buddy."

Hedy thought it was Philip who threw the first punch and that was gallant of him as it was his last punch. One short jab to Philip's jaw and he dropped to the floor.

The muscle man turned back to Hedy, "Listen, I have a car out back and we could go to another place."

The Baron stepped forward, "Look here, young man."

And the man did, dropping the Baron next to Philip. Now the Baroness grabbed a bottle and broke it over the muscle man's head stopping him for only a minute before he tried to pull Hedy out the door.

"Hedy!" the Baroness screamed grabbing her arm but

ripping off her blouse instead. For one quiet moment Hedy stood naked to the waist then there was a whooping holler like an Indian on the warpath and furniture started flying along with fists. Bottles crashed and splattered against the wall and an all out brawl began. It lasted 15 minutes before police arrived.

During the melee Hedy noticed the young steward taking pictures then a flying chair hit him in the back and he ran out of the building. When they booked her along with the bedraggled others she was only half conscious. Philip kept yelling for a doctor as he took his shirt off and put it on her then rubbed his aching jaw.

The Baroness was yelling at a policeman, "This is absurd. The real culprits got away and les innocents are in jail!" She circled the cage restlessly but it wasn't till the next morning that everyone was released.

Back on the yacht the Baron ordered the crew to set sail for the mainland immediately. The peaceful quiet of the ocean breeze belied the worlds' new chaos. Everyone sat on deck quietly depressed when suddenly the Baron bellowed, I think it's time to tell that story about President Roosevelt."

"No," the Baroness protested, "don't tell it."

"Why not? We need to change the atmosphere. As the story goes our President was drinking with some friends and talking about a possible war when he said, "Well, I've been in war and I've been in Eleanor and I'll take war!" He and Philip laughed but Hedy and the Baroness didn't.

Hedy got up saying, "I'd better go pack."

Back in her cabin she put clothes in a suitcase then opened a porthole window and took a deep breath of sea air. Glistening silver pathways of sunlit water appeared to roll right into the

city and she thought, 'Three days and still the marriage wasn't consummated. Maybe that was an omen.' Stepping out of her cabin she bumped into the steward who had been taking pictures.

"Oh, excuse me," he rushed by flustered as she stared after him. His manner bothered her but at that moment the ships engines slammed into reverse telling her they were about to dock.

Chapter 10

ARE WOMEN BETTER?

Whether women are
better than men I can't say,
I can say they are no worse!
Golda Meir

"How could you do this to me!" Beldins voice boomed across Hedys' living room. "I've invested in you. I've fought for you."

"I fought for myself," she said calmly.

Undaunted he continued, "The marriage was bad enough but a naked bar room brawl too!" He shook the photographs in her face. "Twenty Thousand for these prints and negatives. I should tell the blackmailer to print them. Maybe then you'll learn to behave."

Her headache returned as she looked at the pictures. There were a couple of her in the midst of the barroom chaos and two of her being carried out nude from the waist up by two policemen. She sighed, "It could have been worse."

He groaned, "Don't tell me that," he thumped his chest, "it hurts here."

She sighed again, "I knew there was something suspicious about that steward. I should have followed him into his cabin."

"God forbid!" Beldin slapped his forehead, "Who knows what he might have photographed there!"

She laughed, "Well, it's no use being so upset about such a small thing when we're at war now."

She flipped on the radio and a repeat of President Roosevelts' speech was on.

"My fellow Americans, the sudden criminal attacks perpetrated by the Japanese in the Pacific provide the climax of a decade of international immorality."

Beldin flipped the radio off. "It's a good thing the world is in a state of immorality. By comparison you don't look so bad."

"The world is full of crooks. I'm just another victim." She moved closer to him, her perfume was stronger than his cigar smell. In a soft tone she said, "You know I'll make millions for you and the studio. Pay off this blackmailer and let's get on with negotiating my raise."

"No," he shouted, his jowls quivering as he shook his head.

Hedy took a deep breath, pushing her breasts almost out of her dressing gown Beldin's attitude mellowed, "Hedy, you could have so much. Let's talk about this unfortunate episode in your bedroom." He pulled her arm and she reluctantly followed. He sat on her bed sighing, "You're such a problem child."

Those words she had heard many times from her father. That's what irritated her about him, he reminded her of her father.

He was talking and rubbing her hand over his groin, "Oh Hedy, you never say yes to the right people! I'm the one who can really help you." He unzipped his pants and pulled her down to her knees. His erection was very hard for an old man and he pushed Hedys' mouth over it and groaned, "I knew one day you'd come to your senses. I told Anak he couldn't change you with that masseuse."

Hedy stopped but he forced himself into her mouth pumping and moaning. She didn't expect him to stream forth like a rising tide. "Oh my God," he sighed falling back on the bed.

A second later she bent over him and spit the semen on

his face. He jumped up sputtering as he ran for the bathroom. A few minutes later he came back saying, "Hedy, that is not the way you're supposed to do that!" He put his pants back on and said, "I'll see you tomorrow at the studio."

When Philip came home that evening she told him she had an argument with Beldin about a blackmailer who had taken pictures of their barroom brawl. She said she got so upset she spit in his face but omitted the sexual part.

Philip laughed, "Well you just declared war on Beldin but he's probably used to women spitting on him. You know he owned a Burlesque theatre before he started the studio?"

"Yes, he's very rich and he should give me a raise. We need to buy a house."

Since their marriage Philip had moved into her apartment because he had been living with his father.

He shrugged, "As long as we don't have children this apartment is big enough."

She stared at him a moment then said, "At the rate this marriage is going we'll never have children."

He frowned, "There's plenty of time for children." He smiled and hugged her.

She stared at him a moment then said, "Why don't we have a quiet dinner at home tonight. I'll fix us a couple of Martinis."

"Good idea. I'll go take a shower."

When he returned to the kitchen she had prepared cheese omelets and two large Martinis. She had turned on some Glenn Miller music, lit candles and donned a filmy red negligee. She soon pulled him into the bedroom. They finally had sex but it was over so quickly Hedy was frustrated.

"Philip, "she said trying to be diplomatic, "your sweet and I love you but your lovemaking is too…too polite."

He laughed, "Thank you, I think." Then he rolled over and went to sleep.

She laid next to him wondering if Gunther had ruined her for anyone sensitive. But he wasn't a very exciting lover and her thoughts drifted to Dorita. She went to the bathroom, masturbated then returned to bed and fell asleep.

During the next week she learned that Beldin had paid the blackmailer $10,000 and that he was now willing to give her a raise. She guessed it was not out of his generosity but rather that he was afraid she might tell someone what happened between them. But she was glad for the raise and went back to work.

One afternoon as she was walking from the commissary to a sound stage she bumped into Nord. "Hedy, marriage agrees with you. In fact, I don't know if the painting I'm doing is going to flatter you or not."

"Oh, are you painting me?"

"Yes, darling, now that you're married to the Gallery himself maybe you could arrange that showing for me?"

"He's very booked right now. I couldn't tell you which one of us is working more, I've seen so little of him."

"Oh, has the marriage come to that already?" Nord said sarcastically.

Hedy felt a flush of anger but she was quick with a retort, "No, it hasn't reached the point of yours!" and she walked away.

Nord stared after her and mumbled, "OK, Bitch, the battles on!"

When Hedy got to her dressing room she knew what really made her angry was he had guessed the truth. Something was

wrong with her new marriage, it felt like an old marriage. What went wrong?

When she walked in the door that night Philip had a Martini waiting for her. She sat on the couch and sipped it looking at him, "You know now that we're settled into marriage we should think about buying our own home."

He sighed, "Alright, if your heart is set on it."

"Good, I saw a beautiful mansion in Bel-Air this afternoon. We had to quit early because of a faulty electric circuit so I took the opportunity to look at some homes with a real estate agent."

Philip paled, "Why a mansion? Couldn't we start with something quaint like a cottage?"

"Oh Philip, really, we can't live like ordinary people. We're celebrities. If you can't afford it I'll buy it myself."

"I can't let you do that."

"Why would it dent your masculine ego? I got my raise and I'm making more than you right now."

"That's the point, I'm not a gigolo." He set his glass down. "I have a business appointment, don't wait up for me." He slammed the door behind him but he still heard her glass crash against it.

Then the phone rang, "Hello beautiful, how's married life?" It was Anak. She hung up on him. He called back, "That bad, huh?"

"If you're so worried about my welfare why didn't you propose?"

He laughed, "That would have given my wife and children a bad case of insecurity. Actually, I called to say goodbye for awhile. I have to return to Greece. But if you need anything Tony

Jacobs will be in charge of the studio while I'm gone. So if Beldin gets too obnoxious come over to us."

"Some choice," she said sarcastically.

Anak sighed, "Somehow I feel marriage isn't the answer for you."

"Yes, I got your massage message."

He laughed, "Ah Hedy, you know I adore you. You could be such a fantastic Sex Goddess."

"Could be?"

"Well, we'll work on that together."

"Goodbye Anak, have a miserable trip!" She heard him laugh as she hung up but now she was depressed. What does a woman do when she's depressed? She buys something. She promptly bought the Bel Air mansion.

It sat high on a mountain top overlooking both the city and the ocean. When Philip saw it he could only think of the cost but his father was there and said, "This is a perfect setting for a jewel like you, Hedy."

Hedy preened under his gaze, "It will be a nice place to raise children."

The older man grinned and nodded. Philip just kept looking around.

The thought of children represented normal to Hedy and normal was an important word to her. "I think I'll take a little vacation and become a housewife for awhile."

Philip laughed, "That'll be the day!"

She glared at him, "I may even start painting again or composing music with George.

Philip said nothing but went to the bar and fixed himself a drink.

Chapter 11

BEAUTIFUL PATRIOT
Oh beautiful for patriot dream undimmed
by human tears.

In 1943 you could almost smell red, white and blue in the air at an American bond selling rally. Patriotism coursed through the spirit of every American and actors made personal appearances to raise morale and money for Uncle Sam.

Hedy eagerly waited in the wings of a bond selling rally while the announcer yelled over the wall of noise that anyone who bought a $10,000 bond got a kiss from actress Hedy . The ladies in the audience were offered the debonair Charles Ballad for their bond purchase.

During the shouting, stomping and squealing, Hedy and Charles walked on stage waving and smiling.

A young sailor ran up the stage steps yelling, "I just blew a years pay but it'll be worth it!"

Hedy smiled, grabbed his sailor tie and kissed him like she really meant it. He nearly fainted during the applause but managed to walk off stage shaking his hands over his head like a winning prize fighter.

For an hour the two stars talked to and kissed the various bond buyers then they were replaced by Tory Sontoug, Gentry Sloan, Mady Jackson and her new famous husband cowboy star Rod Briar. Mady had done only one film but managed to marry the star which automatically made her a celebrity.

Backstage a party was going on but Hedy just wanted to go home and looked around for Philip. She sat down on a nearby couch to wait for him. Gentry Sloan was complaining to his agent,

"Hollywood is the only town in the world where they stab you in the back then call the police and have you arrested for harboring a concealed weapon!"

His agent laughed but shook his head, "No, it's Washington, D.C. Politicians are worse than whores. At least with whores you get something for your money but with politicians you just get screwed!"

Hedy laughed and Gentry turned around, "Oh Hedy, would you like some tea or a drink?"

"No, thanks, Philip is supposed to pick me up now." She looked around annoyed that he wasn't on time.

Tory came up to Gentry and kissed his cheek. Hedy guessed they were dating but it hadn't hit the fan magazines yet.

Philip came running through the door, "I'm sorry but you know traffic and there are police at every door."

"Didn't you tell them you're my husband?" He nodded. "Well come on, I'm tired and I want to go home."

They left as the loud speakers blared forth with Kay Kyser's recording of "Praise the Lord and pass the ammunition."

Philip drove their new Rolls Royce slowly through traffic. Hedy said, "Can't you drive faster?"

"I don't want to dent this car. It's twice as expensive to fix than other cars."

She sighed, "You worry about trivia."

He said nothing more all the way home. In fact, for the last six months he seemed withdrawn and sullen and their communication was infinitesimal. But Hedy refused to admit that her marriage was a failure.

As soon as they walked in the door, Philip went straight to the bar. Hedy went upstairs to their bedroom and undressed. She

admired her nude figure in the mirror then clasped her hands over her breasts. They weren't sore or swollen and her abdomen was flat. Last month she thought she might be pregnant but obviously she wasn't. If she was going to have a baby she should have it now before she passed 25. She scrutinized her face. They were no signs of aging so she decided to put on her sexiest black negligee and go downstairs.

Philip was slumped on the sofa staring into the amber liquid of his drink; He had kicked off his shoes and propped his feet on the coffee table.

"Philip, darling," Hedy said in a sultry tone, "why don't you come to bed?"

He looked at her a moment then looked back at his drink.

"Philip?"

He sighed, "Hedy, it's not working. I can't keep living off of you. It's embarrassing. I can't afford this house or the car."

"Philip, a star must live up to her image."

"What about my image? I look like a gigolo instead of a man."

"If you'd act like a man you'd earn more!"

"I can't make a lot of money with an art gallery during war time."

"That gallery's an obsession with you. That college boy you hired acts like you're God and those old society matrons fawn over you like you're the King of England. And you preen like a Peacock, accepting all that false adulation."

"Maybe it makes me feel like a man!"

"Man!" Hedy yelled, "If you're so much of a man how come I'm not pregnant?"

His eyes narrowed, "Maybe you're not much of a woman!

Maybe you're a female impersonator like Nord!"

He barely saw her hand flash out before it struck his face. Instead of taking it like a gentleman he slapped her back. She was stunned but then her temper came back to burn like her crimson cheek.

"Philip, you're a phony from your title to your bank account and you're the worst lover I've ever had!" She scornfully shrieked the last.

Frustrated and feeling tears in his throat he yelled back, "You ought to know. You act like a Bitch in heat!"

Again her palm struck his face but this time he grabbed the front of her lace negligee and ripped it down while she kicked at him and screamed obscenities. During the scuffle she tore his shirt open and clawed his chest. He put his hand over her mouth and she bit his finger. They fell to the floor with him on top.

He heard himself saying, "I hate you, Bitch!"

In the midst of their struggle he felt himself becoming aroused and pressed in her groin still screaming as shrill as a woman, "I swear I'm going to kill you!"

Brutally he pushed himself inside her. She was surprised because for the first time he became forceful, plunging into her depths as his fingers tightened around her throat.

Hate spewed from his mouth so fast spit dropped with his words, "Fucking, castrating slut!"

Hedy gagged as her throat muscles tightened with fear and his fingers pressed deeper into her neck. The last thing she heard was his agonizing groan of release before lack of oxygen forced her mind into a blank wall. After Philp climaxed he realized she was unconscious.

Tears of bitter disillusion fell from his face to hers. He

had tried hard to make this marriage work. He had tried so hard to prove to his father and to himself that he was a real man. Then he looked at Hedy's pale face and still body and genuine fear overtook him.

"I've killed her," he sobbed. Then he ran to get a cold, wet cloth and came back to lift her to the couch. He heard her moan.

Chapter 12

MARRIED MEN
All men make mistakes, but married men find out about them sooner!

Thick Technicolor makeup under hot Kleig Lights for six hours of acting would make anybody sick. Hedy complained of exhaustion two minutes before she fainted on the set. She hadn't told anyone she was almost two months pregnant. Her doctor prescribed rest and not working but bills kept coming in and Philip had closed his gallery for lack of enough business to pay the overheads.

Beldin had a limousine drive her home and suggested a day of rest. Quite generous for him. When she entered her home she saw Philip at the bar reading a paper. He looked up, "Hello, how'd it go today?"

"It's hard work, but you wouldn't know about that!"

"Hedy, don't start on me."

Sighing she sat on the sofa and asked, "Did you talk to Beldin about getting a job at the studio?"

"I made my call but he didn't return it."

"Philip, I'm pregnant!"

A moment of disbelief then he asked, "Are you sure?"

"Yes, the doctor confirmed it."

"Then are you going to stop working?"

"If you start!"

"Ok, I'll call Beldin and I promise to chase him."

"Good, I'll just finish this picture and take a vacation."

He sat down next to her and took her hand in his. It was a compassionate gesture that had been missing in their marriage. At

that tender moment the housekeeper announced dinner was ready.

The next day Philip called Beldin again but as usual didn't get through. However, this time he went to the studio and waited in Beldin's outer office. After Beldin found out Hedy wasn't working he granted Philip an interview.

"Well my boy how's Hedy?"

"She's pregnant."

"No!" Beldin was appalled. "How many months?"

"About two."

"Oh my God and we've got at least another three months of shooting." He shook his head. "How could you do this to me? It's such bad timing."

Philip ignored that. "Mr. Beldin, you probably heard my gallery closed."

"Yes, war time, people can't afford paintings right now."

"Well I need a job. Hedy thought you might find something for me in production or set decoration. I'd like to know how I can help?"

"You should have asked me that before she got pregnant."

"I'm asking for a job now."

"Hmmm, well when is Hedy coming back to work?"

"I haven't asked her."

"OK, that's your job. See to it your wife finishes this film as soon as possible."

"But I don't want a nursemaid's job."

"No, no, your job is very valuable to this studio. If Hedy doesn't finish this film we'll lose millions. You'll be assistant to the producer."

"How much does it pay? I want to make what my wife does."

Beldin slapped his palm against his forehead. "I needed this? My boy you can't possibly expect to start at the top. You'll get a fair salary but since Hedy hired that shyster lawyer she is getting a percentage of the picture."

Philip extended his hand, "Alright, your assistant producer is ready for work."

"Good, go home and bring your wife back!"

Actually when Philip got back home Hedy was ready to work. What had thrown her off her schedule was morning sickness. When Philip brought Hedy on the set he just sat and watched her act. But the next day he was helping Nord with set decoration. It was creative and Philip had a few suggestions.

One evening a month later he seemed to be more relaxed so after dinner Hedy asked if he would rub her back. He agreed and went to get the oil she liked. When he returned she was in bed wearing a filmy red negligee. "Sit down dear," she patted the bed next to her.

"Philip, do you love me?"

"Love you, well I wouldn't have married you if I didn't."

"You love me but you don't make love to me."

He shifted uncomfortably, "Well I thought in your condition I didn't want to upset you."

"Really, well you're doing it." She pulled him closer, "Make love to me." She pressed his hand against her breast. He didn't respond and she sensed it.

"Hedy, I'm sorry," his voice was filled with anguish.

Suddenly he felt a resounding slap across his face, "Is that what it takes?" she demanded. "Go ahead, hit me, do whatever you want but do something. Hate me if you must but don't ignore me!"

He got up and left saying nothing but he drank heavily over the weekend. Hedy was disgusted and decided to drive to Malibu and walk along the beach. Nearly five months pregnant and the picture was almost finished but then what? Communication with her husband was hopeless. As she was walking back to her car she noticed a couple strolling in the distance. She slipped into her car and when they got closer she saw it was Beldin and Mady Jackson. An interesting twosome she thought and wondered if he was keeping his benevolent father image with her?

The next day on the set Hedy was sitting in her canvas chair when Nord walked over, "Say Princess you're beginning to show. Good thing you're retiring to hatch that egg." His attitude was condescending as if she had made a mistake getting pregnant then he asked, "What are you naming this miracle Duchess or Baron?" It was his way of saying he knew she was impressed with royalty.

Before she could answer Philip walked up to them. "That rocking chair is in the wrong place for this scene. In fact I think they took the wrong one out of the Prop Room."

Nord sighed, "I'll check the Prop Room."

Hedy said, "That's a nice rocker for the baby's room. Let's take it home."

"You mean steal it?"

Disgusted she answered, "Believe me, this studio is the biggest thief in town."

"But I'm responsible for the props. I can't do that." He started to walk away then turned back, "Oh Nord invited us to dinner Friday night."

"That queen! You go, I need to rest." She stood up and

looked at herself in the mirror. "Look I'm showing, aren't you proud of yourself? Now you can tell the world you're a man but don't try telling it to me." She walked to her dressing room.

When the film was finished the fan magazines clamored for pregnancy pictures with layout stories of her and Philip as the happily married couple. Hedy laughed bitterly when she saw them. She saw even less of her husband since she stopped working and he started. Now he was assistant set decorator on a film called, "Casablanca."

She preferred the original title, "Everybody Comes to Ricks," and she would have had the Ingrid Bergman part if it wasn't for her pregnancy. She thought Ingrid looked like a Nun which was totally wrong for that part. They needed an exotic, sexy looking actress like herself.

She was standing in front of her bedroom mirror when her housekeeper, Ruby, came in to tell her Philip wouldn't be home for dinner. "Wonderful," she groaned as she looked at her swollen belly. She felt itchy and blotchy and said to her maid, "They're all liars, Ruby, there's nothing beautiful about a pregnant woman."

"Yes, Mam," Ruby nodded and went back to the kitchen.

Hedy was in her ninth month and due any day when Jack Byer called and asked to visit her. The moment he walked in she felt apprehensive. "What will you have to drink, Jack?" She asked and walked to the bar.

"Straight Scotch and too bad you can't join me cause I think you'll need one too."

He sounded like she should brace herself for bad news. She poured a Scotch over ice and handed it to him. "It's nice to have company in my waiting days. "How's the Bogart picture coming along? How's Philips decorating?"

He sighed heavily then took a long sip of Scotch, "May I suggest you get Philip the hell out of decorating!"

"Why is he that bad?"

"You must know what's going on, now what are we going to do about it?"

"What's going on?"

"You really don't know? Well I should tell you that Nord never forgave you for not having an art exhibit for him."

"I merely said I'd try, but Philip wasn't interested."

"Well he's interested now!"

"That's silly," Hedy said afraid to hear the truth.

"Nord moved out on me." Jack sighed.

"Oh, I'm sorry."

"You should be if you love your husband because he took my lover away!" He laughed sarcastically, "It's really ironic isn't it, you're now the most famous sex symbol image in the world and you can't even hold onto your husband. That's Hollywood they know how to make an image that's just an illusion."

"Get Out!" Hedy screamed, "I don't have to listen to this trash."

"This trash is your life," he yelled back. "Remember your evening at our house when we spoke about reincarnation? Philip believes you've come back in a woman's body with a man's mind. You're the ultimate female impersonator!"

Suddenly she felt like she had inhaled ether and struggled to refocus her mind.

Jack was saying, "Nord talks about standing outside your own body and dissecting it like a doctor. Have you taken a good look at yourself?"

She felt about to cry and gasped feeling the baby kick at

her lungs then said through labored breathing, "Philip wouldn't leave me for a freak!"

Jack laughed, "Why not, he married one!"

A stabbing pain hit her abdomen and caused her to gasp again.

"Oh, don't tell me I shock you. Or maybe you're so pampered and fawned over in this fantasy town you're not in touch with reality." He struggled to his feet feeling slightly drunk. "Just remember when all the sparkling fanfare fades it's just fizzled fireworks."

He walked out the door slamming it behind him, never noticing Hedy was now bent over and clutching her stomach in pain. She screamed the pain of the piercing cramp inside her.

Ruby came running, "Oh Lord, it's time!"

For the first six hours of Hedy's labor she was semi-conscious but then the sedative began to wear off and the pain brought an agonizing shriek and a doctor to her side. A nurse patted her forehead with a wet towel while the doctor told her to push down. She licked her dry lips and whispered, "I'm tired."

The nurse put a hunk of gauze between her teeth saying, "Bite on this when the pain hits. We'd like you to remain conscious."

She felt like someone was twisting her stomach muscles on a rack. She bit down and the perspiration beaded across her whole body. She spit the gauze out and screamed in convulsive agony.

"It's a breach," the doctor said, "I'll have to do a Caesarean."

Hedy was at the point in her torment where she barely heard the doctor and had crossed into insanity. In a harsh whisper

she said, "I don't want it. Kill it before it kills me!"

Quickly they gave her a numbing shot and the operation was performed. When she awoke the next day a young nurse greeted her saying, "The doctor will be here shortly. I'll bring your daughter in soon."

"A girl?" Hedy asked.

"Yes, a healthy eight pounds."

"Hello," the doctor walked in, "you've got a beautiful little daughter. I talked with your husband and he'll be here soon. Hedy, it's my professional opinion that childbirth is too hazardous for you. Your passage is small and you lost a lot of blood. We had to give you a transfusion so I tied your tubes. If you want to take a chance of having another child we could reverse the operation but I wouldn't advise it. You could die."

He opened her hospital gown and pressed the side of one breast. A white fluid oozed from her nipple. "I suggest you breast feed for the first few days then if you want we could dry you up so they don't stretch too far." He kneaded the loose flesh on her abdomen. "I took a couple of tucks when I sewed you up but I'll give you a list of exercises to do." He closed her gown, "I'll be back in the morning."

At five the corridors were filled with crying, hungry babies. Hedy pushed herself up and winced at the pull of her sore stomach. A nurse came in and handed her a pink blanketed red faced wailing baby.

Hedy looked at the baby's contorted face and said, "That's not mine, it looks like a red faced monkey."

The nurse laughed, "New mothers sometimes get a shock at first glance but yours is cute. Her head isn't all pushed out of shape since you had a Caesarean."

The baby clamped onto Hedy's breast and she winced in pain, "I can't do this." She pulled the baby away.

"You really should try to breast feed for a couple of days. It would be good for both you and the baby. But if you're too sore right now I'll give her a bottle."

When the nurse left, a heavy depression settled over Hedy. All those months of waiting were over and now what? But she didn't have much time to think because Philip walked in bringing flowers. "Hello darling."

"Don't be a hypocrite," Hedy said coldly.

"Don't be a martyr," he countered, "I'm not going to force you to be the long suffering wife. I'll give you a divorce."

"Ha, that's just what you want now that you've found another wife!"

He flinched, "I just saw the baby. She's a feisty little thing but I'll be happy to take care of her if you want me to." She stared at him and he said, "Hedy, I'm sorry we're not compatible."

She laughed bitterly, "But you're compatible with another man!"

Wearily he said, "I'm sure you'll find what you're looking for someday."

"Will I? Will I be as lucky as you?"

He nodded, "I really hope so. You deserve some happiness. You've worked hard and I admire you for that. I hope we can part friends. I'd very much like to share our daughters upbringing."

Hedy stared hard at him, "You must be mad. I wouldn't allow my daughter to be around a pervert!"

He sighed heavily then walked out of the room. All she felt was empty, just empty.

Chapter 13

THE BIBLE; LITERATURE NOT DOGMA
The Bible is literature, not dogma!

Santayana

It took a full year for Hedy to recuperate from childbirth. Even so, she couldn't adjust to motherhood so a full-time nurse was kept at her house. Hedy named her new daughter Brana. When Brana was one month old Hedy had filed for divorce. Beldin was delighted and arrived at her house the day she filed bringing her a $1000 War Bond for the baby. He said with a smirk, "Too bad you had to divorce him. If he would drop dead you'd get better publicity; more sympathy for widows than divorcees."

"Maybe I'll shoot him," Hedy said sarcastically.

"No," Beldin shook his head, "no sympathy at all for murderers! Now if he was a political figure, then assassinations are convenient." He laughed, "Well are you ready to go back to work?"

"Do you have a good script?"

"Yes, an epic. Every time we run out of ideas we run to the Bible. Not to pray but to plagiarize. Victor Mature will be the leading man and you the leading lady."

"I'll read the script."

"It isn't ready, read the Bible in the meantime."

Hedy groaned.

"Hey, there's a lot of action in the Bible with all the begotten and begetting the whole world was formed. Read the Samson and Delilah part."

The nurse came into the room bringing the baby. "Alright send me a Bible I have to take care of the baby now."

"Goodbye mother," his tone was facetious.

In ten minutes the nurse came back for the baby. Now she had nothing to do so she decided to clean her closet. She noticed one of her favorite dresses was missing and called Ruby.

After being questioned Ruby said, "Miz, I hope you don't think I stole it."

"All I know is it's missing."

Ruby walked away in a huff. Hedy thought damn hired help as soon as you befriend them they take advantage of you. The phone interrupted her thoughts.

"Congratulations on your divorce," Anak said.

"Oh, you're back from Greece."

"Yes, after hearing the good news I say let's celebrate."

"I don't feel like celebrating."

"Well, maybe it's too soon. I'll send you a present to cheer you up."

The next day a diamond bracelet arrived. How nice, Anak is gallant, unlike Philip. But she still didn't want to see him. A week later he left town again. She had been reading the Bible and was bored. The radio was playing "Green Eyes" which she was humming to when she thought about calling George and playing the piano again.

He had told her that he wrote music for synchronized piano player rolls and she remembered when Gunther and one of his engineers was talking about using music patterns to guide torpedoes. Maybe together they could create something to use against the Nazis. Music might be the answer.

She called and he was delighted to hear from her. He

could come by that evening if she was available so she invited him to dinner. They got along like old friends and she told him about Gunthers' idea of using music frequencies to guide weapons. To her surprise he knew how it could be done and they began working together. When they finished they applied to the American government for a patent. Hedy wanted to help America and get even with her ex-husband too. They made a date for the following week to compose music for her new Bible epic.

The next day a script arrived and she read it immediately. Two days later Beldin called anxious to hear her acceptance. "Victor and Tory Sontoug are ready to start filming, are you ready?"

"Unhuh," she said sleepy, "the doctor gave me some sleeping pills so I'll call you tomorrow."

Beldin heard a click. Damn, he thought, she's so difficult. He wished he could find a new star to replace her.

Hedy was last to report for work on the biblical epic but she had agreed to the salary Beldin offered. She was sitting in her canvas chair studying the script when Tory walked by with Dorita. Hedy tried not to look surprised as they greeted her and passed on to Tory's dressing room.

Victor came up to her, "Good morning, nice to be working with you."
Hedy smiled and thanked him thinking he looked like a body builder.

There was the usual amount of confusion and noise as technicians set up a temples with pillars that looked sturdy but could be pushed over by Samson. Then Hedy's eyes were riveted to the two men in charge of set decoration. Nord and Philip! She closed her eyes to keep from screaming. How dare Beldin do this to her.

Victor sat down beside her, "Well we go from Bond selling to Bible selling."

Then someone called him away and Philip was standing next to her. "Hello Hedy, you're looking well, how's our daughter doing?"

"If you're so interested why don't you visit?"

"Because I know I'm not welcome but I am interested. I also want you to know that both Nord and I are looking forward to working on this film."

"How are you two newlyweds doing?"

"Hedy, I hope you won't let old animosity spoil our working together."

At that moment Beldin walked onto the set with his secretary, Mary. "Ah good, everyone is here, maybe we can be on schedule."

For the next week Beldin was on the set every morning appearing apprehensive but there were no delays and no outbursts of temperament so he began to relax and openly show interest in Mady Jackson who had a bit part in the film. He thought it was good to have Mady around, it might keep Hedy in her place.

Then one day Hedy overheard Beldin talking to Mady. "You have great potential, I could make you a star. You might even replace Hedy."

"Really," Mady said surprised.

"Yes, why don't you meet me at the Sky Motel next Saturday and we'll discuss it in detail."

Mady frowned, "Are you serious or is this just an afternoon of promises?"

"My dear, I look upon you as I would my own family."

Hedy had heard that before so she thought maybe she

would go to the Sky Motel and see if he did show up. She was waiting outside when he arrived on Saturday and she took a picture of him going into a bungalow. Then she walked around the back and peered in a bedroom window. What she saw and photographed changed her whole future.

Mady was lying on the bed naked when Beldin walked in. He smiled saying, "Now you're what I call a smart girl." He stared at her a moment, "Yes, I believe you could take Hedy's place but you'd have to do everything I tell you. You can't be headstrong like Hedy."

"I'm listening," she said seductively.

Beldin disrobed, kneeled over Mady's face and pushed himself into her mouth.

"Make me hard," he commanded. His urgent selfish need became over stimulated in her wet mouth and when he rammed his penis against the back of her throat and ejaculated he caused her to gag and he heard a gurgling, strangling cry before she fell back on the bed.

"Fantastic," he sighed, "where did you learn to open your throat like that?"

She didn't answer or move and the color had drained from her face.

"Mady?" he put his hand under her breast but there was no heartbeat. "Oh my God," he whispered then shook her but she didn't respond. For a moment he was dumbfounded then he hurriedly dressed, washed his hands and left. Hedy took another picture of him leaving and watched as he sped away.

Three days later the papers broke the story with the headline, "Actress found dead under mysterious circumstances." Hedy read the paper and sipped her coffee. It crossed her mind

that it was really theatrical of Mady to open and close her career in one act! That was the reward she got from listening to Beldin. After Hedy picked up three sets of her pictures at the photo shop she went straight to Beldin's office.

Beldin sat stunned as he stared at the pictures. "I can't believe you would stoop to this. And after all I've done for you!"

Hedy sat opposite him wearing a smug grin, "Yes, I heard you tell Mady how you were going to replace me with her. Well now you're going to do a lot more for me. I want ten percent of the gross from my picture and then we'll renegotiate my contract."

Beldin groaned, "That's blackmail!"

"No," Hedy said standing up, "it's justice!"

Beldin was visibly shaken as Hedy left to return to the set. At the end of the days filming Philip stopped by Hedy's dressing room, knocked and walked in, "May I come in?" He did before she could answer.

Hedy was sitting at her dressing table. "Nord and I would like to invite you to dinner tonight."

Hedy looked at him a moment then said, "Go home to your fairy tail and leave me alone."

"Hedy, I know how you must feel but there's so much more to life than most people realize. Nord showed me who I really am and he has changed my whole outlook for the better."

"How lucky for you," she said brushing her hair.

"Hedy, you could live in a beautiful world too if you'd stop looking at people as male or female and realize all that matters is if they're good people or bad and if they're good for you or not."

"Don't think that statement justifies your behavior."

"I'm not trying to justify anything, I'm just trying to help you understand yourself better."

She turned and stared at him, "You've been in the closet too long, your mind is moth eaten."

Suddenly he grabbed her arm pressing his fingers into her flesh, "I'm asking you to join us tonight because I'm the father of our child."

"Alright," she said wresting her arm away from his painful grip.

That evening Hedy sat quietly in Nord's living room sipping a Martini and thinking nothings changed except Jack Byer has been replaced by my husband.

"How's Jack?" she asked.

Nord stiffened, "I haven't heard from him. I guess he's not as understanding as you are.:"

She had to laugh at that and Philip said, "Ah good, you're happy at last." He turned to Nord, "Why don't you light the barbeque now?"

After Nord left the room Hedy said, "Are you really happy now, Philip?"

"Yes."

"Then how come everybody says homosexuals aren't normal and can't be happy?"

"Who's everybody?"

She shrugged, "Doctors, society, people, the Bible."

"Someday people will be better educated and I think that mindset will change."

Nord came back in, "Hey it's such a hot night how about a little swim before dinner to work up an appetite?"

"I didn't bring a swimsuit."

"Oh Hedy, you're so modest, well there are a couple of women's suits in the bedroom closet. Put one on and jump in, you look too tense."

"I think I will," she said and walked into their bedroom. She pushed some men's suits aside and was surprised to see her missing dress hanging on the back wall. So it wasn't Ruby it was Philip but why?

"Did you find them?" Philip asked sticking his head in. "They're on the top shelf."

Hedy turned around and asked, "What is my dress doing in your closet?"

Philip blushed and stuttered, "Oh, ah, I wanted to have something of yours as a keepsake."

"Not true," Nord said walking in. "He likes to wear women's clothes too, and that dress stretches."

"You're disgusting," Hedy said.

"Ha," Nord retorted, "look who's talking. Dorita's a friend and I heard all about your massages!"

Hedy ran out of the room, grabbed her purse and slammed the door behind her.

Nord yelled after her, "You're a cross between the Virgin Mary and a Hungarian Whore!"

"Damn," Philip sank down on the bed. "I wanted us to be friends. She is the mother of my daughter."

"How unlucky for you," Nord said flatly.

The following day Hedy went through her scenes like an automaton. She said her lines but there was no emotion in her acting even after the director yelled at her. He called for a break and she went to her dressing room and took three pain pills.

Beldin's secretary Mary knocked on her door and entered, "Don't you feel well, Miss ?"

Hedy was lying on the couch feeling sorry for herself but she said, "Poor Mary, you don't know what life is all about but I understand."

Mary looked confused, "Is there anything I can do for you?"

"Have you ever given a massage?"

"Oh yes, sometimes Mr. Beldin gets tense and I massage his shoulders."

Hedy sighed, "Good, see if you can do that for me." She took her blouse off and rolled over on her stomach. Mary's strong fingers gave Hedy a warm sensuous feeling bringing back memories of Dorita. Suddenly she rolled over and pulled Mary down on top of her, I understand not having love," Hedy whispered.

"Please," Mary struggled pulling back, "I don't think you do understand."

In a flash Hedy awoke to reality and yelled, "How dare you touch me, get out!"

The totally confused secretary backed out the door and Hedy yelled, "That's what I get for doing charity work!"

The next day Beldin was on the set but Mary was absent. He walked over to Hedy, "Have you seen Mary? It's not like her to be late."

Hedy coolly said, "I wanted to talk to you about that poor woman, she tried to seduce me."

"Mary?" Beldin was incredulous, "Mary, never!"

"Well, perhaps seeing me nude was too stimulating for her. You should fire her."

"Fire her? My God, I wouldn't know what to do without her. She's the most efficient person working here. Takes dictation, answers mail and the phones and makes and cancels my appointments. She even sees I eat right and fixes my drinks and makes me take vitamins."

Sarcastically Hedy said, "Why don't you stick a broom up her ass so she can sweep the floor at the same time!"

That incongruous statement made him burst out laughing, "Hedy you're a woman of contradictions but you've got a good sense of humor."

Hedy shrugged.

"You know," Beldin said, "I really admire your capabilities too. Why can't you trust me?"

"I trust you but I cut the cards."

"Ah yes, well I have to find Mary."

She watched him walk away and wondered how long it would take her to assume the lead in the studio chain of command. At least now she knew he would not dare to replace her. Beldin studios had no real competition except maybe Anak. The thought of him stirred a mixture of love and hate, rather like the way she felt about Gunther.

HEDY- ALWAYS IN CHARGE

Chapter 14

KEEPING AHEAD-SECRET OF SUCCESS

*Keeping ahead of
conditions is the secret
of a successful
business.*
Anak 1946

It had been a fearsome war for the Greek common man
even though Greece had declared neutrality. Italy's Mussolini
had sent troops to try and capture her but Greek guerrilla fighters
kept that from happening. Still the people were suffering some
hardships from the occupation.

However, as in every country during a war there are a
few citizens who manage to make a great deal of money. Anak
Stanislaus was one of the favored few. From the time Anak was 13
and pitched pennies on the docks with sailors he had a knack for
making money. At 16 he turned his father's small import business
into an import/export shipping empire. Now at 40 he had a fleet of
cargo ships and was negotiating with Britain to buy refrigeration
aircraft to export produce. During the war he accepted money
from both sides for the use of his ships.

He enjoyed manipulating monies in any business but
the one that amused and fascinated him the most was his movie
studio. He devoted as much time as possible to developing scripts
into films and actresses into women. He felt only a real woman
could be a great actress and he was still working on Hedy.

He also owned the Athens Tower building where his
penthouse overlooked the city and harbor that led into the Sea
of Crete. Today he was listening to his assistant, Tony Jacobs,
expound on the next Paradon project. "I think now that the war

has ended that audiences want more realistic films."

Anak smiled, "You find a realistic film that borders on being condemned and we'll do it."

"I've found one called 'Open Attack' and I think Tory Sontoug is perfect for it."

"Tory?" Anak said thoughtfully, "yes she'd be easier to get than Hedy and she's not married. Where is she?"

"In Rome but I think we could have her here in a few days. The right part still means more to her than anything else from what I hear."

"Get rolling," Anak commanded.

A special messenger was dispatched to Tory's apartment in Rome but she wasn't there. She was in the midst of a party at Prince Caref's palace in Istanbul. Amid the revelry of about 200 people she drank and attempted to learn belly dancing. Her blonde hair was wildly disheveled and her blue eyes luminous next to her creamy flushed complexion.

Dama, the youngest of the Prince's 12 wives was attempting to teach Tory the art of the ancient Belly Dance.

"Did I roll my stomach muscles right?" Tory asked.

The dark haired beauty nodded shyly, "You are good the way you roll them from here." She put her fingers under her small breasts and against her café-au-lait bare midriff. The thin veiling material of her harem top and pants barely covered her body.

Tory asked, "Do all the Prince's wives know how to Belly Dance?"

"Yes, the Prince enjoys the art very much."

"Who wouldn't?" Tory laughed.

Prince Caref stepped through the crowd of revelers looking regal in his white suit and turban. "Has the youngest of my wives taught the Hollywood actress how civilized people dance?"

"I'm learning," Tory smiled at him admiring the Blue
Sapphire stone hanging from the middle of his turban and resting
on his dark forehead. Jewels had started their conversation at the
diplomatic party in Rome where the Prince had invited his favored
guests to fly to his palace and continue partying. His palace looked
like something from Tales of the Arabian Nights.

"Tell me," the Prince asked, "what kind of a civilization is
America?"

"America?" Tory said thoughtfully then smiled, "America
went from barbarism to decadence without passing through
civilization!"

The Prince laughed, "Then you don't like the country?"

"Oh, but I do, I just know what her faults are. I also know
what her virtues are and she gives women the chance and the
challenge to have careers."

"Hmmm," he nodded, "I'll give you a challenge." He
reached in his pocket then opened his palm. A large Ruby
glistened like rich, red wine. "If you Belly Dance and disrobe one
piece at a time I shall place this $50,000 gem in your Navel and it
will be yours."

Tory stared at the beautiful stone then looked around the
room filled with European Aristocracy and East Indian Royalty.
With a mischievous grin she said, "Tell the musicians I'm ready."

Caref smiled and bowed then went to speak to the band.
They stopped their music for a minute then began with a low,
throbbing drum beat. Tory stood in the middle of the dance floor
and conversations stopped in mid-sentence.

Caref made no introduction but all eyes were riveted to
Tory's rhythmically swaying body as she slowly began to remove
her low cut pink sequin blouse.

After she dropped that to the floor her long, white satin skirt followed and the drummer hastened his beat to the rhythm of a jungle beat. Undulating her body from the waist down she rolled her white satin panties to a fine line across her hips allowing her audience to see only the uppermost blonde hairs. Her full breasts overflowed the delicate white satin bra.

While everyone was being titillated by Tory's Belly Dancing Anak's special messenger entered and wearily spoke to the nearest servant. "Could you tell me where I might find Miss Tory Sontoug?"

Like everyone else in the room the servants eyes were riveted on Tory and the messenger only had to follow his gaze to become equally hypnotized by the spectacle.

Now Tory danced naked and as she twirled past a group of people she grabbed a white Chiffon Scarf from a nearby woman and flipped it between her legs to act as a sheer veil as she slowly bent backwards until her forehead touched the floor.

The Prince stepped quickly from the crowd with the Ruby between his teeth and kneeled over Tory placing the stone in her navel. Then he snapped his fingers and a servant brought a gold brocade robe that he placed over her. She slowly rose and the applause was loud and long. She had the stone in her hand then bowed and waved to the crowd as she walked off center stage and soft cymbal music began.

"Well done," Caref said as he walked beside her. "You earned that Ruby. Now stay with me tonight and you may become my new wife!"

Tory caught her breathe but smiled diplomatically, "Thank you but I heard you already have 12 wives and 13 is not my lucky number."

At that moment a tall, handsomely rugged looking man walked up to her. "You were fantastic. May I introduce myself, I'm Wendall Jerome, great white hunter." He grinned at her.

"Great white hunter of what? Tory laughed.

Before he could answer the messenger interrupted, "Excuse, please, Miss Tory Sontoug?"

"Yes."

He sighed, "Thank God, I thought I'd never find you." He handed her a letter. "Mr. Anak Stanislaus wants you for the lead in his next picture. I was supposed to bring you back yesterday."

Caref said, "But no, please you must stay at least a few days more."

Jerome said, "You could stay with me forever!"

Tory smiled, "Why is it always all or nothing at all?"

Caref said, "If you stay, I will match the Ruby with an Emerald."

Tory groaned, "I'd like to accept your hospitality but at another time. I have a contract with Mr. Stanislaus and I must fulfill my obligations. Something tells me this might be a turning point in my career."

The messenger said, "Mr. Stanislaus has his plane waiting for you at the airport."

Tory turned to Jerome, "Perhaps we shall meet again. Another time, another place."

Jerome smiled, "Anytime, anyplace."

Tory could still hear music playing as they drove through the iron gates. She had little time to change but had hurriedly thrown her things in a suitcase and put on a pantsuit. In the limousine she relaxed thinking she would be glad to get back to work and perhaps the party wasn't over but just beginning.

Chapter 15

TACT

*Tact is making your
point without
making an enemy.*

Tory landed in Athens a few hours later and was taken
to Anak's office. He smiled as she walked in, "I like you Tory,
you've always been honest with me. I'm glad Beldin dropped
your option and I picked it up before anyone else could."

She sat in a large leather chair in front of his desk. "I'm
glad you picked it up too."

"You know," he continued, "for a long time I only liked
one type of woman, Prostitutes!" I felt those women were
honest. At least they gave you something for your money but
now I've expanded my thinking. Some others are honest and
some prostitutes aren't. Now you, being from Sweden are more
continental and sophisticated."

Tory was nodding and thinking she could learn a lot from
him.

He was saying, "So can you be ready for work in two days?"

"In one day!"

He smiled, "We're going to get along fine."

'Open Attack' was in its sixth week of shooting when Tony
Jacobs entered Anak's office for a conference. "It looks like Tory
will give Hedy competition in the Sex Goddess department. The
cameramen are walking around on three legs."

Anak laughed, "I hope she affects audiences like that.
He glanced down at papers on his desk. "Now let's talk about
expanding the company. What's happening with Beldin?"

Jacobs lowered his voice although there was no one else in the room. "Something strange is going on. He's been making pictures that have barely broken even and rumor has it that he made them because Hedy wanted to and she got a percentage."

"What?" Anak looked surprised, "The last I heard they were at each others throats. I can't believe he would take business suggestions from her." Anak frowned, "Find out what's going on. I'd like to buy that studio. If a man put the movie business to proper use he could control the world through the propaganda of entertainment."

Jacobs held his breath, world control? Then he said, "World control without war? Hitler never would have understood that."

Anak nodded, "Alright, go out and start gaining control."

It took only eight months to finish 'Open Attack' and Anak was pleased with the result. His movie managed to put down hypocrisy and do it entertainingly. The release date was August 1947.

At completion Anak invited Tory to one of his palatial homes on the Greek Isle of Milos. He also invited another Scandanavian movie star and a famous American baseball player. Tory asked if she could invite Prince Caref and Dama. Anak was happy to please her.

Aboard Anak's 100 foot yacht there was plenty of Champagne and Caviar. The only sober ones were the crew and even some of them were suspect. Being always a connoisseur of feminine pulchritude Anak enjoyed both the white blonde beauty of Tory and the dark exotic glow of Dama. Looking at his small group he said, "I'm happy you're all here. This promises to be a delightful little vacation." Anak sat down next to the Prince and the Steward handed him a drink.

The Prince smiled saying, "It is nice of you to invite us on your island."

"It's not my island but you being a world traveler will appreciate seeing Milos. They discovered the statue of Venus de Milo on the isle in 1820." Anak winked, "Personally I've discovered a few Venuses there too."

The Prince smiled but Anak couldn't tell if he was an ally or a competitor. When they docked Anak had a stretch limousine waiting to drive them to his mansion. It resembled a sun-bleached Moorish castle. All the rooms were connected by adjoining doors and an intercom system allowed Anak to speak to every room. He could also listen to every room. An hour after they arrived Anak announced via intercom that everyone was welcome at the pool for an afternoon swim.

An hour later the warm breezes lulled the group into a holiday spirit as they lounged around the pool area. Anak and the Prince sat at the pool bar and admired the female beauties around them. Anak's gaze lingered on Dama and the Prince tapped his arm, "I like my wives to be appreciated but not too much."

"Yes," Anak smiled thinking he'd better distract Caref a bit, "there are two things you have an abundance of in your country, fear and ignorance and religion is the foundation of both. Don't you agree?"

The Prince was a bit surprised, "Interesting, what do you base your opinion on?"

"Common sense," Anak said and sipped his drink.

The Prince half smiled, "The common people don't use their common sense and I am grateful to religion for keeping them in control."

"Yes, my friend, it is good for both of us. But in all honesty

you must agree that blind faith is stupid and ignorance is one of the world's worst sins. The people should be educated enough to be creatively productive and not just to be baby makers."

The Prince shrugged, "I need a lot of servants and wives but if they think independently I may not have so many." He looked from Anak to Dama and said, "I do not wish to share my wealth."

"Neither do I, darling," The Swedish actress walked up to them smiling from behind her dark sunglasses.

"Greta," Anak said, "sit down and have a drink with us."

"No thank you, I want to be alone so I can thoroughly appreciate the beauty of this magnificent day."

Anak smiled, "Women, you're so unpredictable." He watched as Greta took a glass of water back to her lounge.

"My wives are predictable," the Prince said.

Anak looked back at him, "But of course, a Harem must do your bidding. But for me that takes away the challenge. Your faith believes in bigamy, mine says it's a sin. We must have had different founding fathers, mine was a prude." Anak laughed but his humor was unappreciated by the Prince.

"There is only one God," Caref said stoically.

Anak raised an eyebrow, "One God who teaches different doctrines to each faith."

Anak took his glass, "But excuse me, my friend, we'll talk later." He walked over to Greta. "You must come to my screening of 'Open Attack." I just read a script you would be perfect for."

"No, darling, I've worked enough. I want to be alone now."

Anak glanced at Dama and Tory and whispered to Greta, "Right now I'd like to attack those two Aphrodites."

Greta smiled, "That shouldn't be too hard for a Greek God like you but what are you going to do with the husband?"

Anak groaned and looked out at the ocean and an idea came to him. He walked back to Caref. "Do you like deep sea fishing?"

"Yes very much."

"Good, then we'll go tomorrow morning."

"I'd like that," the Prince nodded.

Then Anak went back to Greta. "I think I've solved my problem but where is your baseball player?"

"Out walking around the island," she answered.

"Good," then Anak dove into the pool.

At dawn the next morning the Prince was escorted to a small fishing boat anchored below the villa. But instead of Anak greeting him he was met by a stranger.

"Prince Caref, I'm Peter Sten, Mr. Stanislaus wasn't feeling well but he didn't want to disappoint you so he asked that I accompany you on this fishing trip."

"Oh, I," Caref hesitated but the boat was already leaving the dock and heading towards the sea.

Sten opened a tackle box, "I hear you're a real sportsman and I thought you might be interested in these fishing lures from Scandinavia."

Caref was flattered and the two men began discussing the best way to land a Sailfish. Anak watched as the fishing boat disappeared over the horizon before clapping his hands and ordering breakfast. He knew exactly what his houseguests were doing by listening on his intercom and by reports from his Japanese houseboy. The baseball player ran around the island and came home with another young man.

"What's happening,Taka?" Anak asked as the servant pulled a gold breakfast cart to his bed."

"American ball player take home beach boy last night and play ball."

Anak laughed spilling his coffee, "And they always blame us Greeks for that. Well see if you can get my assistant, Mr. Jacobs, on the phone."

Anak had finished breakfast when Taka handed him a phone. "Tony, where do we stand with the Beldin deal?"

"I don't know yet. Hedy seems to be calling the shots at the studio." Transatlantic communication crackled over the wires. Anak shouted, "Find out what the hell's going on and call me at my Athens office next Monday."

Taka took the phone back and said, "Ladies up for breakfast at the pool."

Anak donned his bathing trunks and went to join the girls. Dama was swimming and Tory was lounging by the pool. It was another beautiful day in Paradise.

Anak sat down under the umbrella table next to Tory, "Too much sun can age that beautiful white skin."

She squinted at him, "It's not too much yet."

A cool breeze floated in from the Mediterranean bringing the scent of Jasmine. Tory stood and Anak appreciated her taut body under her silver swimsuit. She fastened her hair with a tortoise clip on top of her head then lowered herself into the pool. Anak watched the two women float by each other and began to swell under his trunks so he dove into the cool water and came up alongside Dama.

"Does the Prince appreciate your beauty as much as I do?"

Dama blushed and swam away.

Taka called from poolside, "Telephone call, Mr. Gunther Hockstein."

"Gunther?" Anak reluctantly got out of the pool and went to the phone, "Gunther?"

"Hello Anak, I'm in Athens and I have a business deal you might be interested in. Can we meet soon?"

"I'll be back next Monday. Call me at my office."

"Good, what do you hear from my wife?"

"You're wife?" Anak laughed. "She's probably working on her third husband by now."

"Then she's a bigamist. That Mexican divorce wasn't legal."

"You don't mean you still want her back?"

"Most people don't understand, Hedy, she's very insecure. The fault of her parents."

"Not your fault, huh?" Anak sighed, "Gunther, my friend, by the age of 20 it's time to stop blaming your parents. But we'll talk next Monday." He hung up thinking Hedy will still have to deal with him. How unfortunate.

The baseball player, his new boyfriend and Greta joined them at the pool. Greta wore a large straw hat and glasses over her swimsuit but Anak could still tell she looked tired. Greta sat next to him at the table while the men went into the pool.

Anak looked at the two men then back at her. "Titillate my senses and tell me what you're doing with them?"

"Watching."

"They allow that?"

"They love it."

Anak sighed, "I hope my two will."

"They're too old," Greta said.

Anak laughed, "Eighteen is too old for you. In America you'd be arrested."

"That's why I don't live there." She looked at the sky. "I'm going shopping. See you later."

After an early dinner Anak arranged to show a cowboy movie to his guests. Twenty minutes later Tory went to her room and ten minutes after Dama went to hers. Anak waited a few minutes then snuck out and went to his bedroom where he buzzed Tory. "Cowboy pictures may be boring to you but perhaps you'd enjoy seeing a film that can't be shown publicly starring Hedy."

"Hedy, hmmm, yes."

"Good come to my bedroom as we must be discreet."

He then buzzed Dama and said, "Tory wants you to join us in my bedroom for another film."

Tory arrived and was sitting on the bed when Dama came in. "Hi Dama, you think you're old enough to see this?" Tory laughed but Dama was confused.

A large screen hung on the wall and a projector was at the foot of Anak's bed. Anak patted the bed next to him and Dama sat down. The projector was now showing the evening at the Indian restaurant with Hedy in the oil bath with two men and three women.

Tory squealed, "I see it but I don't believe it."

Dama sat quietly but looked fascinated by the sensuous scene. The film lasted almost 40 minutes then Anak switched off the projector and turned on a pink light. Both women were staring at the blank screen.

"Now girls, don't disappoint me and say you disapprove of Hedy's behavior."

Tory said softly, "I disapprove."

"Oh come now, what about Dorita?"

"She was only my masseuse."

Anak looked disappointed, "And all this time I've had such beautiful fantasies of you with her."

Tory had to smile at that. "I wonder what Hedy is doing now?"

Mischievously Anak answered, "Everyone she can and the good ones twice!"

Tory smiled then asked, "How did you ever get her to do that film?"

"Hedy doesn't know about this film, but someday I may show it to her."

Tory laughed, "The day you want to die!"

Dama sat quietly listening but now Anak found himself feeling awkward for the first time in his life. He thought all he had to do was get these two together, set the mood and everyone would fall into bed. But now no one was falling. How very disappointing then suddenly they heard a great commotion in the hallway and much shouting just before Prince Caref burst through Anak's bedroom door.

"Ah hah," he yelled looking like he'd been buffeted through a wind tunnel."

Dama gasped, "Did you have an accident?"

"I've been through Hell trying to fix the boat's engine and falling overboard or being pushed, I'm not sure which."

Peter Sten was standing behind him, gave Anak a shrug and left.

Anak apologized, "I'm sorry to hear you had so much trouble but come join us for a drink and relax. We were going to watch a cowboy movie." He then offered Caref a glass of Whiskey. "Here this will warm you up."

Caref eyed him suspiciously but since they were all fully
clothed and nothing seemed amiss he accepted the drink and
slumped down in a chair. He took a long sip then looked at Anak,
"Just because I have a Harem does not make my wives Hetaerae."

"Of course not," Anak said gently, "you are my friend."
Caref seemed to relax a little and Anak continued, "But I got a
business call from my office so I have to return to the mainland
tomorrow. Could you all be ready by ten in the morning?"

Caref finished his drink, took Dama's hand and said,
"We'll be ready."

After they left Anak looked at Tory, "We lost that loving
feeling."

"What are you looking for," she asked, "love or just sex?"

"Just sex."

Tory smiled and began to undress.

Anak sighed, "Scandinavians are great people."

Upon his return Anak called Gunther and that night they
had dinner at the Fez restaurant. "So now," Gunther was saying,
"there's all this German salvage from the war that can be bought
cheap but I need someone else like you who also has factories.
I respect your business acumen and thought we might try this
venture together."

"Perhaps," Anak said thoughtfully, "but I'd have to see it
myself."

"Of course, the sooner the better."

Anak smiled, "I never rush in business matters."

Gunther sighed and took another sip of his wine. "Since
you have gone into the motion picture business I have also
become interested. Perhaps I could buy the studio Hedy works at."

Anak blinked and cleared his throat, "Gunther, my friend,

if it's Hedy you want then save your money. I have a feeling she will return to Europe soon. It's much cheaper to make films here and her last film didn't do well in America."

"But in the meantime she could get married again," Gunther sighed

"I doubt that but so what? Hedy will never stay married she's too restless. Besides now she has money of her own and the child she wanted and still being the world's most beautiful woman feeds her ego."

Gunther frowned, "She thinks she's the worlds most beautiful woman?"

Anak smiled, "Well that's how Hollywood and the Fan magazines describe her and I think she believes it too. She's insatiable."

"You make her sound like a Maneater."

"Well?" Anak grinned you should know.

"No," Gunther shook his head, "even when she left me she didn't take all her jewels."

Anak thought a moment then patted Gunther's arm, "Then don't worry she'll be back."

Chapter 16

EVERYTHING'S UNDER CONTROL
If everything's under control you're not going
fast enough!
Mario Andretti

Hedy shouted across her large living room at Beldin, "I don't care if you think it's not wise. I like this script and I'm going to produce, direct and star in it myself and you're going to back me."

"But there's only so much I can do in the way of financing. Your proposed budget is too high."

Hedy was proud that she had gained control over Beldin in the last three years and that he came to her house for their discussions. "Maybe I'll make this film in Europe. Things are cheaper there and I'm sure I could find willing investors. Besides, America doesn't appreciate me. George and I gave them a great invention for the war and they didn't even use it."

"They won without it," he muttered.

She ignored that, "Besides my daughter is nearly eight and I've got to think of the future. I can't depend on anyone but myself to secure it for me."

"What about that psychiatrist you've been dating, does it look like marriage?"

"He can't afford me."

"Neither can I." Beldin had aged in the last three years. His polish had dulled and he didn't look well. Often he didn't feel well. Mady's death had weighed heavily on his conscience.

Nevertheless Hedy was exacting, "You better make sure your budget expands to my needs or your needs will cost more than you can afford."

He sighed, "Hedy, I'm getting old and stress isn't helping me age less. I'd really like to retire soon. You already have some of my stock so think of it as your studio."

Hedy scoffed, "You won't retire till you're dead. I don't intend to wait till judgment day for my fair share."

Beldin stood up, shook his head and left.

Hedy arrived in London in April 1949 with her daughter, a governess and 12 pieces of luggage. Her arrival was heralded with a barrage of publicity even though the city was still digging out from the ravages of war.

Surprisingly it was only a few days before Gunther called her at the Dorchester Hotel, "From your picture in the paper you look as beautiful as ever."

Hedy caught her breath as she immediately recognized his voice. She expected he would try to get in touch but she hadn't expected it this soon. "Hello Gunther, I imagine the war treated you well." She tried to sound calm.

He laughed, "Yes quite well, now my darling wife; I think you've played your star game long enough. It's time to come home."

"I'm not your wife anymore but whether we are married or not isn't important. A more important question is would you like to invest in my new movie? You could double your money."

"When can I see you," he ignored her question.

She hesitated then said, "Tomorrow at noon. We'll have lunch downstairs." She hung up and smiled. Maybe he hadn't learned in the past few years but she certainly had.

The elegant hotel atmosphere lent itself well to Hedy's discussion of millions but Gunther was hesitant. "I would only be interested in a partnership with you if you put up half and I'll put up half."

He had the look Hedy knew well, that of a gimlet-eyed banker. She didn't like his proposition but she would be tactful. "I'm not afraid to invest in myself," she smiled seductively.

He studied her a moment, "Hollywood has changed you, you have more confidence in yourself."

Hedy looked at him then tried a different ploy, "I'm disappointed you didn't suggest a welcome home party for me"

"If you're really coming home we'll have one."

She smiled, "Touch me, I'm home."

"Well, perhaps you're right. It's time Europe got some of its gaiety back."

A week later Hedy had her Gala Soiree in the Dorchester Hotel Ballroom.

Notables from England, Austria and Germany attended along with celebrities and press.

Everyone signed her guest book. There would be certain wealthy ones she would invite for private cocktails. As the guest of honor she floated charmingly through the crowd until Anak stopped her.

"Hedy," he smiled, "how could a beautiful woman like you give me business competition?"

She smiled back, "Oh, would you like to invest in my film?"

"I'm sure you'll get all the investors you need without me."

Hedy frowned, Anak seemed too impersonal. She saw Gunther staring at them from across the room and Tory was standing next to him. "I see your new star is here."

"Yes, I thought you might like to join us tomorrow for a yacht party."

"Really Anak, another one of your orgies? I make love

with my mind not just my body." She turned on her heel and walked away.

Her words were too perfect. He remembered hearing them in one of her pictures. Too bad Hedy kept acting even behind the camera.

A tall, handsome man dressed in a tuxedo and a Stetson cowboy hat took Hedys arm saying, "Why don't you fold up these cardboard people and I'll take you to a real party."

"Am I supposed to know you?"

"We met briefly on Stage 22 when you were shooting a religious picture and I was doing a Western next door. My names Vance Greer."

"Excuse me," Gunther took her arm, "may I have this waltz." He pulled her onto the dance floor as the orchestra played the Blue Danube and asked, "When are you really coming home?"

"Perhaps when I finish my new film."

"Then I'll get you my half of the financing and you can begin next week."

Hedy said nothing but after they danced she began to drink Champagne and by two in the morning she was intoxicated. Gunther escorted her to the Penthouse and she kissed him lightly on the cheek, murmured she was tired and closed the door. He didn't press the situation. He would bide his time until he could get her back permanently. As soon as Gunther left Vance Greer stepped from around the corner and knocked on Hedys door.

Hedy answered the door with half her dress off, "Gunther, I told you…" She stared at the cowboy and he grinned down at her.

"I'm glad you anticipated what I had in mind," he said enveloping her in his arms.

There were few occasions when she lowered her image to expose her vulgarity but this was one of them. She pushed him back forcefully and yelled, "Fuck you and the horse you rode in on!"

Then slammed the door in his face.

He groaned, "Oh lady, not the horse." Then he shuffled to the elevator.

Chapter 17

MEN DESTROY EACH OTHER

Do not men die fast
enough without
destroying each other?

Gunther waited patiently for Hedy while she made arrangements to take her daughter and the nurse with her to visit him in Germany. She thought of it as a visit, he thought of it as a permanent move.

But once Hedy was back inside the castle walls she began to feel uncomfortable.

Unpleasant memories flooded her thoughts and she knew it was a mistake to return. The Butler had taken the nurse and child to their quarters and now she stood alone with Gunther in his grandiose living room. The antique Steinway with its black grand piano hauteur was still gleaming proudly in the midst of magnificent Louis the 14th furniture.

"That's new." Hedy pointed to a mantel clock.

"Yes, a gift from Adolf, it's too bad he had to die. He always asked about you. You were his favorite actress. He could never forget the night the three of us were together. I still have the gold cigarette case with the Diamond Swastika that he gave you."

"Keep it," she said flatly.

"Oh, come now, we had fun together."

"You mean as children," her tone was derogatory.

"Children wouldn't enjoy the games we played." His sinister smile made her think he would be a perfect movie villain.

"Come sit by me," he said, "I have your favorite Montrachet Wine."

"I prefer Chateau Lafitte d'Rothchild now."

"Ah, your taste has also become more sophisticated."
He pulled a wall rope and when the Butler came he ordered the
Chateau Wine.

After they had both taken a glass of wine he toasted,
"Here's to the new woman you've become. I sense even more
exciting and dangerous."

She smiled, "You've changed too and your change of life
has given you better insight."

"That's why I find you fascinating. You're every other inch
a lady!"

Their personal war began again. "I hate you for what you
did to me," she said coldly. "You're no better than a killer."

Gunther shrugged, "Who is more to blame, the killer or
the killed? The two have a polarity, just like we do. At 16 you
had centuries of living in your eyes. I only brought out what was
already there." He sipped his wine. "Shall we play the game,
Hedy? I'll give you a thousand dollars for your dress."

Yes she thought, I'll just tease him. He deserves it. She
began to unbutton her dress and let it drop to the floor.

He smiled, "And for your slip, two thousand."

She dropped it to the floor. She wore no brassiere.

"Three thousand for your lace panties." She slipped the
black lace down her thighs slowly then kicked them into his face.
He caught the delicate material and savored the musk aroma. She
stood before him in high heels, nylons and a garter belt.

"How much Hedy, how much are you worth now?

"More than you can afford!"

He laughed and she grabbed her fallen dress and ran up the
stairs to her old bedroom. He hadn't changed anything; the peach

canopy bed, the gold velvet chaise, her white and gold dressing table. She opened the closet, put on a red satin robe when Gunther came in and she gasped. Standing behind him was a tall African man.

Don't worry, Henri is deaf and dumb. I found him working in a whorehouse. He has a unique asset from an accident. The muscle under his tongue was severed." Gunther motioned for the black man to open his mouth. His tongue fell out like a long, pink snake.

Hedy couldn't speak nor could she move as Henri lifted her onto the bed placing her legs over his shoulders and inserting his tongue into her vagina. In a few moments she was writhing in ecstasy and Gunther was masturbating near her face and sprayed cum over it. In a moment she felt the Africans penis ripping into her but a minute later the men left her lying on the bed crying when Hedwig, her personal maid, came in.

"Why did you come back?" Hedwig asked but Hedy didn't answer so the maid went to the bathroom and ran hot water into a large marble tub. She added perfumed bath salts then went back to help Hedys tortured flesh into the soothing water. Hedwig gently washed her back with a face cloth.

"I'm glad you're still here," Hedy said softly. "I was afraid he might have punished you when I left."

"He did, he let the Germans kill Ervin during the war." Ervin was Hedwigs husband. The maid sighed, "But maybe the dead are the lucky ones, at least the pain is gone."

Hedy said nothing and after 20 minutes Hedwig helped her out of the tub and back into bed. She brought her a nightgown then some warm milk and a tranquilizer. She sat on the bed and stared at her mistress. Hedy looked ethereal without makeup and

with her Auburn hair flowing free over the peach satin pillow.

The maid said, "Now that you're back he'll never let you go again."

Hedy opened her eyes, "When it's time I'll leave, just as before."

"But he'll be more careful now." the maid protested, "He's learned from past mistakes."

"So have I, Hedwig, so have I."

At the lunch table the next morning Gunther talked of many things but not a word of the previous night. Then he said, "You still need me. Why don't you admit it? You'll never be free of me."

She gave him a cold stare, "Someday I will, even if I have to destroy you."

He burst out laughing, "I like that, it's stimulating."

Hedy got up and walked out on the balcony. Gunther's backyard looked like the Garden of Versailles. Brana was playing on the grass with the nurse close by.

Then Gunther came up beside her, "I didn't know you could have children. Is she really yours?"

"Yes, but I can't have anymore."

"Good, then you don't have to worry about a black bastard."

Hedy slapped his face but he only seemed to enjoy that. She turned on her heel and went to her bedroom. When she sat on her bed a sharp pain brought back the previous night's activities but she knew after one of Gunther's debaucheries his physical appetite was satiated for weeks, sometimes months. Only his mental purge was incessant. Well she would not let him defeat her. It was who won the war, not who won the battles.

She glanced around the room and remembered a wall safe behind an ocean painting. She pulled the picture aside and entered the old combination. It opened and all her glittering friends were still there. A 30 carat Emerald, a 20 carat Diamond ring, a blue Sapphire and Ruby necklace. She touched them and shivered with erotic pleasure. She would never leave them behind again.

A week passed and Gunther was busy with business but wherever Hedy wanted to go she was chauffeured and body guarded by Henri. One afternoon she decided to call Anak.

"How long are you going to stay there," he asked. "I have a new script that's perfect for you. Better than the one you were going to do."

She sighed, "I don't know, I feel like I'm at the crossroads of my life. Maybe I should retire."

"I don't believe you'll ever retire. I don't know what your motives are there but Gunther is no fool and he thinks of you as his possession."

"I'm no ones possession," she bristled then hesitated, "but if you have a good script for me then come here for a visit and bring it with you."

"Hmmm, maybe I will, that might be good for both of us since I'm already doing some business with Gunther. I could come next Tuesday, you're good news day."

She laughed, "Fine, then I'll see you on my good news day."

She didn't hear Gunther come in but when she went back to her bedroom she found him looking through her lingerie drawer. He turned and held up a pink Dildo, "I see you've become a gadget addict."

"That belongs to a friend."

He laughed, "And you're keeping it warm for her. Well don't worry I'm not going to steal your toys. You probably needed this when you were married to your last husband. I heard he walked around like this." He put one hand on his hip and swayed across the room, pirouetted, raised an eyebrow and pursed his lips.

"You're doing that too well," she said disgusted.

He immediately dropped his effeminate act.

She stared at him, "I know you've been investigating my life but I think I understand you better now too. I have a psychiatrist friend who consults with me."

He laughed, "He consults with you!"

She nodded, "You really hate women."

"Hate is an emotion. You once told me I was incapable of emotion."

"I've learned a lot since I said that."

She possessed too much self-assurance, he felt nervous and she sensed that.

"You once told me I could lie to the whole world but I must be honest with myself. Why don't you take your own advice and admit you're a homosexual?"

"You're a depraved Bitch," he shouted angrily.

She smiled, "Depraved Bitch? Well that should make you happy."

He tried to regain control but she was determined to prevent that. "Is your first wife still in an insane asylum? Did you always want to see her with other men too?"

"Watching sex is an erotic stimulus, everybody normal enjoys that."

"You think you're normal?"

"Just as much as you think you're normal!"

"What about your brother?" she said.

He stiffened, "You know my brother is dead."

"Yes, because of you! You're so power hungry you took his business and destroyed him."

"No, not true, he was incompetent."

"Only after you broke his spirit."

Gunther frowned and slumped into a chair, "I loved my brother."

"Really? You told me after your mother died in childbirth you blamed him for it even though you were only eight. In your mind her death was a personal rejection and you've hated women ever since."

For the first time since she had known Gunther he looked about to cry. Then abruptly he got up and left the room. For the next three days he disappeared but on the third night he came into her bedroom accompanied by a voluptuous blonde woman. She giggled, teetering slightly and he pushed her onto Hedy's bed.

"Here, I've brought you what you want," his words were slurred. He was drunk and so was the woman.

"Get out," Hedy said disgusted.

"Why Hedy, you're so damn anxious for me to face the truth about myself, why not you?"

Hedy folded her arms and glared at him.

"Relax," he said taking a bottle of Gin from his briefcase. "Have a drink with us. You'll like Helga. She's soft and full of love. Isn't that what you want, love?"

"I'm not interested," she said flatly.

"Oh, you're interested but I didn't know you were afraid to take what you want."

He pointed to Helga, "She's almost as beautiful as you but

she only speaks German. She's seen all your movies and she loves
you. Isn't that marvelous, to love someone you've only seen in a
movie?"

"It's childish."

"Yes, the whole world is childish."

"Where did you find her, another whorehouse?" Hedy
asked.

"What difference does it make she loves you and that's
what you like, love, love, blind love."

Hedy was infuriated at his mocking, "Get out and take
your whore with you."

For a moment they glared at each other then he said,
"She's moving in. I've hired her as my personal secretary." He
took Helga's arm and left Hedy to her thoughts. Her thoughts
were confused; he had never brought another woman into their
relationship."

For the next few days she saw Helga around the house but
didn't speak to her only nodded. Then late one night she went into
the kitchen for a glass of warm milk because she couldn't sleep.
Helga was sitting at the kitchen table eating a sandwich. The two
women nodded at each other and Helga watched Hedy get milk
and heat it.

When she poured the warm milk into a mug she turned
to go back to her room and Helga smiled at her. She hesitated,
looked at Helga's voluptuous body, full lips and sensual blue eyes
and decided to drink her milk at the table. Helga stopped drinking
and ran her tongue around her tea cup. She slowly wet her lips all
the while staring at Hedy with a languid look. Then she slowly
ran her fingers down Hedy's arm. Hedy's stomach flipped and she
sighed. Helga waited a moment so Hedy could fully appreciate

her abundant breasts and erect nipples visible through her blue nightgown then she languorously walked to her room. Hedy followed.

She stood in Helga's doorway watching as the other woman slipped out of her nightgown and rubbed scented oil around her breasts and between her thighs. Not one word passed between them but they communicated completely. Helga laid down naked on her bed. Hedy quietly closed the door and lay down beside her leaning over to kiss Helga's lips. The two women fused together with Hedy taking the lead by sucking Helga's nipples into glowing rosettes. She moved her body slowly over Helgas' until her feet started to tingle and her legs trembled. They moaned their pleasure to each other and the intensity climaxed with simultaneous shuddering and collapse.

Slowly Hedy pushed herself up and left. But on leaving she wasn't as cautious as she had been on entering and she closed Helga's door loud enough to wake Gunther. He got out of bed, opened his door and saw Hedy walking down the hall to her room. He frowned. Had the two women been together without him? He burst into Helga's room and she looked asleep. He shook her, "Helga, what was Hedy doing here?"

Helga was afraid to tell him and said, "Talking."

He pulled the sheet back and looked at her nakedness. "You're lying!" He slapped her across the face. "I told you not to touch her unless I was present." She shook her head but he slapped her again. "Get out! Get out of this house immediately."

Then he went to Hedy's bedroom and burst in upon her as she was taking a bath.

"So you did it!" he shouted.

Hedy was startled but regained her composure quickly.

"Can't you see I'm taking a bath."

"Don't try to wash away your sins."

"You're crazy!"

"Am I? You told me you weren't interested in Helga. Then what were you doing in her bedroom? And don't try to tell me you were talking!"

"I never said a word to her," Hedy said truthfully with a condescending look. "Oh Gunther, you're such a plebian peasant!"

"Plebian peasant! Well while you're sitting there on your royal ass I've sent Helga away. You'll never see her again." He waited for her reaction.

"How unfortunate for you. You'll have to find a new secretary."

She stepped from beneath her sheet of bubbles and wrapped a bath towel around her body sighing as she passed him on the way to bed. She slipped between the covers said, "Good night." Then, turned off the bedside light.

Now he was confused. What if they hadn't been together then he had just ruined his own plans. Plans that would have put Hedy back in her place.

As he walked out she said, "Anak will be coming in tomorrow, remember?"

Gunther grunted and left the room.

Chapter 18

TEMPTATION

*The only way to
get rid of temptation
is to yield to it.
Oscar Wilde*

When Anak arrived Hedy greeted him at the door with a kiss as the Butler took his suitcase upstairs.

"Missed me huh?" Anak squeezed her then nodded after the Butler, "Where did tall, dark and gruesome come from?"

"He's Gunther's bodyguard but don't try talking to him he's a deaf mute."

"Interesting, where's Gunther."

"Out somewhere on business."

At that moment Helga walked into the front room. "Well hello," Anak grinned then turned to Hedy, "How thoughtful of you."

Hedy looked surprised then Helga spoke to her in German, "I came through the back door after I saw Gunther leave. I wanted you to have my address and phone number."

"Thank you," Hedy took the slip of paper, "but you'd better leave now."

As Helga departed Anak groaned, "Not fair, Hedy, you sent her away before we got acquainted."

Hedy stared at Anak a moment then said, "Well if you wish, you can take her to the party I'm having for you. I can call her later."

"What party?"

"Just a little welcoming party for you tomorrow night. Come sit down and have a drink."

"Thanks, I'll have Scotch and Soda," Anak said sitting on the sofa.

Hedy went to the bar and fixed two drinks then handed one to him and sat down. "Anak, you and I may be able to do business together again as long as you never tell Gunther anything personal about me."

He toasted his drink to her, "Don't worry, a gentleman is always discreet when it comes to intimacies about a lady." He pulled a script out of his briefcase, "This is the script for you."

"I'll read it tonight," she promised, "now what would you like for dinner and I'll tell the cook. Then I'll show you to your room as I want to play with my daughter later. Gunther is usually back by dinner time."

At dinner that night the two men talked about their business deal and Gunther arranged for Anak to see more scrap material the next day. Hedy excused herself and went to her room.

She phoned Helga, "How do you feel about Gunther?"

"He's sadistic, I hate him," Helga answered.

"Yes, well we need to turn the tables on him. Will you help me?"

"How?"

Hedy thought a minute, "Well, for a long time I didn't think he had any weaknesses but now I think I've found one. It's the man you met yesterday. Gunther likes him very much and that's unusual because he has no real friends. I analyzed why he would like Anak and then it came to me. Anak looks very much like Gunthers dead brother. Gunther once told me he felt responsible for his brothers death, I just don't know why."

"Just tell me what to do," Helga said.

"I want you to come to a party here tomorrow night. It will

be in honor of Anak and I'll have him pick you up. You'll be his date."

"But your husband told me never to come to your house again."

"If you're Anaks date there's nothing he can do about it. I'll tell Gunther that Anak knew you previously."

"I'll do whatever you want me to do."

"Good, the party will start at seven. I'll send Anak to pick you up. It will be an interesting evening."

Chapter 19

EVILS OF DRINKING

When I read about
the evils of drinking
I gave up reading!

Henny Youngman

"Lord and Lady Stocbough," Gunther had hired an English Butler for the night and he announced arriving guests. The orchestra played Viennese Waltzes as the formally attired guests came to the party. Sixty people had been invited and all attended. Then the Butler announced, "Madame Helga Verner, Mr. Anak Stanislaus."

Gunther looked up from a group he was talking to, excused himself and went to find Hedy. She was talking to the French Ambassador. Gunther had an impulse to jerk her around but instead politely said, "My love, may I speak with you a moment."

He took her arm and led her away. "What is Helga doing here?"

"Helga?" Hedy said innocently and looked around. "Oh, Anak's date. Well, I'm surprised that you wouldn't know your friend is quite notorious for knowing women like her."

A waiter passed with a tray of drinks. Hedy took one and handed it to Gunther, "Here dear, you need to relax and enjoy the party." She smiled and glided away as Gunther stared after her. He gulped the drink down. Well, maybe Hedy was right, it's possible Anak would know a woman like Helga and that made him laugh.

"Anak," Hedy said approaching him, "Gunther admires your taste in women."

Anak grinned, "I'll share her with him if he'll share you with me."

Hedy smiled, "I feel a strange excitement in the air tonight." Then she turned to greet another guest.

By two in the morning the guests had left and Anak, Gunther, Helga and Hedy were sitting at a table drinking and enjoying each others company. Anak sighed heavily as he looked from Hedy to Helga. Both women were wearing low cut gowns.

Hedy looked at Anak, "Is there something you'd like?"

Anak rolled his eyes up and Hedy laughed saying, "Is that right."

Anak turned to Gunther, "Well, my friend, now that everyones left let's have our own party."

Gunther looked at Hedy, "I have a problem wife."

Anak grinned, "I'll be glad to help you with your problem. Why don't the four of us go upstairs and talk about it."

"Anak, you must be mad," Hedy said.

The moment Gunther thought Hedy didn't like the idea he said, "Good idea, we'll go to Hedy's suite."

He didn't see the smile on Hedy's face as she turned to go upstairs. Anak could hardly believe what was happening. He hadn't even hoped for this much but he didn't hesitate. He grabbed a bottle of cold Champagne and four glasses. The moment he got to Hedy's bedroom he removed his tuxedo jacket and unbuttoned his tie and stiff white shirt. Then he poured everyone more Champagne.

Anak handed a glass to Gunther, "My dear friend, I had no idea from our business transactions that you were such a refined aristocrat.

Helga and Hedy had gone into the bathroom together and

emerged wearing black and beige negligees. "Follow my lead," Hedy had told her.

An audible sigh of visual delight escaped Anak's lips than he said, "I must get something special from my room." He returned wearing a brown satin robe and put a small yellow box on the bedstand. "This is a treasure I discovered while visiting an English Duchess, one sniff and you're in heaven."

Hedy was not about to sniff anything but she smiled as Gunther came out of the bathroom wearing one of her satin robes. He sat next to Hedy and Anak sat next to Helga. He was more drunk than the others and Hedy sensed that tonight he wouldn't be the instigator.

Anak whispered something in Helga's ear and snapped a small vial under her nose. One whiff and she moaned and Anak pushed her closer to Hedy. Helga's negligee parted allowing her breasts to touch Hedys and Gunther got a diabolical expression thinking this was just what he had planned originally. Helga was softly kissing Hedy and Anak snapped a vial under her nose. The aroma made her slightly dizzy and she fell back on the bed with Helga next to her. When Hedy opened her eyes Gunther was lying next to her but staring at Anak. Hedy took one of the vials and snapped it under his nose. He inhaled deeply and moaned, "Kolan."

Hedy knew Kolan was Gunther's brother's name. Gunther reached over and began to caress Anak's buttocks mumbling, "Kolan, I love you," and then he tried pushing his erection into Anak.

Anak jerked out of Helga, "Wait a moment, my friend…"

Then Hedy whispered, "Don't stop him, he loves you." She quickly grabbed another vial and snapped it under Gunther's nose.

Gunther swooned moaning, "I won't hurt you, Kolan."

Anak pushed him away. Gunther angrily said, "Don't do that I'll kill you, I'll…" Suddenly he broke down crying then screamed at a bewildered Anak, "I warned you, its your fault." He collapsed at the foot of the bed and sobbed uncontrollably.

Anak looked at Hedy who now had a Mona Lisa smile. "What's happening?"

"Anak take Helga home I want to talk to Gunther alone."

Anak shook his head, "No, Hedy, you've done enough."

Gunther was trembling and still crying when Anak pulled him to his feet and the two men left the room.

Early the next morning when the servents came to clean they found one guest asleep on the floor behind the sofa. The servents whisked him out the door but he resented the indignity and his loud cursing woke Hedy. Helga was lying next to her asleep.

"Helga," she shook her, "you must go now before Gunther wakes."

Helga slowly opened her eyes, shook her head and pushed herself out of bed. "I don't understand this whole situation between you and your husband, it's crazy!"

Hedy flinched at that word and immediately wanted Helga out, "I'll explain later but you must go now."

After Helga left Hedy freshened up, donned a flowered housecoat and went to her daughter's room.

Brana was sitting on the floor with her dolls, she looked up, "Good morning, mother" addressing her formally as if she were speaking to a stranger.

"Good morning, Brana." Hedy sat next to her on a chair and watched the child play and talk to her dolls. Hedy

was reminded of her own lonely childhood and the lack of communication with her mother. Suddenly she swooped down and scooped the little girl up in a bear hug.

"Mommy, Mommy, you hurt me," her daughter was frightened by the sudden burst of emotion.

"It's alright, honey, Mommy just wants to say she loves you." Hedy kissed the child and squeezed her again but Brana was trying to squirm out of her arms.

"Mommy you're scaring my friends."

Hedy released her, "What friends?"

The child scrambled back to her dolls saying, "It's alright, Suzie, Mommy won't hurt you."

Hedy frowned, "Brana, you don't have to talk to dolls, you can talk to Mommy."

Brana was holding the doll tightly and patting her head when she turned her soulful eyes to her mother saying, "Mommy's never here when I want to talk but Suzi's always here."

Hedy felt deep sympathy, "You're eight years old now and I promise I'll be around more."

Then Hedy heard voices in the hall and she got up to leave, "Honey, we'll talk again later."

Hedy opened the door and saw Gunther being carried out on a stretcher. Anak was standing at the top of the stairs and walked over to Hedy, "Gunther had a nervous breakdown and a heart attack. He's been incoherent and one side of his body seems paralyzed so I called his doctor and he sent an ambulance to take him to the hospital. Your maid and his valet are going to accompany him."

Hedy frowned, "I could have taken care of him here."

"No," Anak stared at her, "frankly I think he's going to

need a long rest in a Sanitarium. I'm not sitting in judgment of you. I'm sure he deserves everything he gets but I don't appreciate you making me the object of his affections."

Hedy had to laugh, "Come, we need to talk, we'll have breakfast out on the patio."

They spent the morning discussing Anak's new script then he asked, "Are you going to continue living here?"

Hedy thought a moment, "I really want to spend more time with my daughter but how long do you think Gunther will be gone?"

Anak shrugged, "No telling, it could be a month or even a year. Nervous breakdowns are both mental and physical."

She rationalized, "Well he was headed for a breakdown the way he drives himself."

Anak laughed, "And you helped give him a needed rest."

She looked disgusted but said, "I think you should go back to London tomorrow and I'll try to get there in the next two weeks."

"Will you be ready to sign contracts and give up that other film you wanted to do?"

She nodded, "But I'd like to be co-producer as well as star."

"I think we can work that out." Then he smiled, "Shall we continue were we left off last night?"

"You're incorrigible."

"Yes fortunately."

She sighed, "Well I have a lot to do before I leave so please pack and make arrangements for your own departure. I'll call when I arrive in London."

She got up, kissed his cheek and walked back into the

house. He stared after her lustfully but decided not to risk a breach with his future star. Sex and truth were still stumbling blocks for Hedy.

The next day after Anak left, Helga called and Hedy told her she would be leaving in a few days and she didn't know when she'd return. But, Helga should not try to get in touch with her and Helga sensed it was goodbye.

Then she called the hospital and found out Gunther's condition had deteriorated, he'd lapsed into a coma and was not expected to live. She was actually relieved to know that chapter of her life was finally over. The next week she made travel arrangements for herself, Brana and the Governess to go to London.

Her maid asked, "But what if he doesn't die? Then I'm sure he'll come looking for you again. You're an obsession with him."

"Somehow I believe things have changed. Here I want you to have this." Hedy said giving Hedwig the gold and diamond cigarette case Hitler had given her and a Ruby ring from Gunther. "I doubt that I'm still in Gunther's will but perhaps you are. But in the meantime you could sell these items and have a nice little savings account for your future." The maid thanked her and took the items to her room.

Three days later Hedy left Germany forever.

Hedy rented a flat close to Anak's London studio and commenced negotiations for her new film. A month passed, contracts were signed, monies made available and Hedy went back to work. But two weeks into shooting she threw a tantrum on the set and stormed off. Anak was called to the studio.

He sat in her dressing room listening to her complain that she didn't like the director.

"Hedy, making movies has changed. It's more business than artistic. There is no time for temper tantrums. You'll have to go back to work today or," he hesitated, "well you might be interested in seeing a film of yourself taken one lovely night in an Indian restaurant and Myer might be interested since I know he's a connoisseur of stag films."

Hedy looked shocked. For the first time in her life she was speechless then she said softly, "I thought you were my friend."

"In order to have a friend you must be a friend. You've built a wall around yourself and that's a waste for a beautiful woman."

"You're immoral," she said flatly.

He smiled, "I believe the moral code is the set of values emanating from the behavior of people in general but I happen to know the behavior of people in general is not what they say it is. Now I do have high business ethics and my word is my bond. When I made a deal with you to do this film I expected that your word was equally reliable."

She thought a moment, "If I finish this film on time will you give me the negative to that film?""That could be arranged but I was looking forward to the time when we could both enjoy that evening together again. Unfortunately this day arrived before that one. But if you go back to work immediately the film will be yours."She got up and returned to the set.

Chapter 20

Psychiatrist

*A psychiatrist is a man who
goes to a strip club and watches the audience.*

By now time has passed and Hedy's daughter Brana has blossomed into a real blonde beauty who has begun college. Two young men see her at a campus dance.

"Wasn't her mother a big star a few years ago?"

"Yea, a 40's Sex Symbol. Her image was everyone's dream." The young man talking was Devon Bresk, an American. His friend, Bob Shinton was born in England.

They were standing on the sidelines of the annual freshmen introduction dance where Princeton mingled with Sarah Lawrence.

"Let's go over to her," Devon said. "I'll introduce you and you can introduce me."

The two boys elbowed their way through the crowd till they stood next to Brana.

They quickly introduced each other and Brana smiled a greeting saying, "My names Brana Bolton."

She resembled her mother in exquisite beauty but there was a softness about her that Hedy never had. Her hair was ash blonde and her eyes a blue green.

"You're a freshman, aren't you?" Devon asked.

"Yes, I'll probably find it a bit strange here because I've had European schooling."

"Don't worry, I'll help you," Devon smiled as the band started playing. "Hey, let's twist." He grabbed her arm and pulled her to the dance floor.

Bob shook his head thinking Americans are so damn fast he's already got the girl.

When the dance ended he said, "Hey, you're great, would you like to see a movie with me next Saturday night?"

Brana studied him a moment then said, "That would be nice."

Bob came up to them, "Hey Devon, quit hogging the girl."

"Sorry you're too late, I've already dated her for next weekend."

Bob groaned, "That's what I get for having a friend who's pre-med, they cut in right away."

Devon laughed, "Go find your own girl."

When Bob walked away Brana said, "You're pre-med too?"

"Yes, I was thinking of becoming a psychiatrist."

Really my mother's married to a psychiatrist right now. She was going to him so often I think she decided to marry him and save money. She gets depressed quite often now that her career seems to be ended but he's still trying to help her mental health. I'd like to help people too but I was thinking of becoming a General Practitioner."

"But your mothers a famous actress, wouldn't you like to follow in her footsteps?"

"No, I didn't see much of her growing up but when I did she didn't seem happy."

"Nobody has a happy childhood, I didn't either, but we can complain to each other later. I'll be happy to walk you back to your dorm if you like. I just have to tell Bob I'm leaving."

She nodded and watched him walk away. He was a handsome, muscle man who probably worked out everyday. She

smiled as he came back and now looked forward to their movie date.

They went out the following Saturday night and on several Saturdays after that for the next three months. Each time they liked each other better and one night Devon said, "I think I love you, Brana."

They were sitting in his Jaguar in front of her Dorm. He kissed her gently, "I'd like you to meet my parents during Christmas vacation. They live in New York. Didn't you say your mother lives there?"

"She has an apartment in New York and a house in Beverly Hills but she likes New York at Christmas so she'll probably be there."

"Don't you keep in touch?" he asked.

"Periodically."

He nodded, "Yea, my parents are kinda like that, they travel a lot."

She leaned over and kissed his cheek, "Devon, I think I love you too."

"Great, let's go away next weekend. I can borrow a friend's lakeside cabin. It's beautiful there and not too far from here."

"I'd like that."

The following week neither of them concentrated much on studying. Brana's major was pre-med but she wasn't sure what she wanted to be. She was sure she didn't want to be an actress. She had outgrown her pretending stage.

Friday Brana got a letter from Hedy. As usual her mother didn't sound happy. Samual's practice had slacked off and Brana thought no wonder it slacked off, with Hedy's problems he'd have

little time for others. Then Hedy wrote she wanted to return to acting. Well, Brana sighed, there goes husband number three. But how did she expect to return to acting after a 10 year leave? That was a lifetime for an actress. She ended the letter saying she was looking forward to Brana visiting during the next holidays and signed it, "Your loving mother."

Brana thought about love and Devon came to mind but she wanted love to last and that seemed to be an extraordinary feat for most people.

Devon picked her up at ten the next morning. Brana looked more beautiful each time he saw her and even though the drive took three hours he was happy to share them with her. It was a cozy cottage with two big fireplaces, one in the living room and one in the master bedroom.

Devon said, "OK, you unpack the lunch and I'll bring in luggage and get logs for the fireplaces."

Brana was happily doing her chore when he came up behind her saying, "You'll make a perfect wife, you know how to unwrap packages."

"Oh funny,' she laughed.

"Let's eat later and take a walk to the lake now."

The air was fresh and clean as they ambled through the foliage and tall pine trees. At the lake Devon skipped rocks across the water then turned to Brana saying, "What a romantic setting just for us."

Back at the cottage he barbequed steaks and she made a salad. Afterwards when they were sitting in front of a roaring fireplace he took her hand and placed a one carat diamond on her third finger.

For a moment she couldn't speak, then tears welled in

her eyes, "Devon, it's beautiful but there's so much I want to tell you."

"Ok, but before you start, let's have my kind of after dinner drink." He pulled a brown paper cigarette out of his shirt pocket. "Have you tried Marijuana?"

She shook her head no.

He lit it taking a deep drag then handing it to her, "Just inhale deeply." She hesitated. "Come on, you can't get addicted on one cigarette and it'll help you relax."

She inhaled then coughed saying, "I'd rather have a real after dinner drink like Cognac."

"Ok, I have some Brandy handy." He poured her a glass and after sipping some she relaxed.

He grinned, "Now you can tell me about your sordid past."

She half smiled, "Well I never really knew my father and now her third husband is a psychiatrist she's driving crazy."

He shrugged, "Nobody's perfect."

She continued, "I was about nine when mother sent me to a Catholic boarding school for girls in Switzerland. I shared a room with another girl who went away every weekend with her parents and I felt very alone. One night I had a nighmare and cried out. A young Nun came to comfort me." Brana sipped the rest of her Brandy. "I put my arms around her and didn't want to let go. Her night gown was unbuttoned in the front and I sucked her breast."

"Is that all?" Devon asked, "Listen I think most kids go through an experience like that. I remember guys at my boarding school playing with each other. It's no big thing. In Psyche they'd call it regressing. My parents weren't around much either. I've really just gotten to know them recently and I can't wait to tell them about you."

"Really, Devon." He noticed her eyes tearing up. "Hey, I love you." He reached under her blouse and caressed her breasts.

She started to push him away, "No, I've never done this before."

"Trust me," he whispered, "I'll be gentle."

He slipped her panties off then tried to penetrate but she squirmed out of his grasp.

"It hurts," she said.

He groaned then reached for a jar of crème on the bed stand. "Listen, we've gotta find out if we're compatible. What kind of marriage would we have if we're not?"

He rubbed crème over her clitoris until she moaned then suddenly he was pushing inside of her but in a few moments it was over. "Oh God, I'm sorry, but you're so tight. I'll do better next time."

Tears rolled down her cheeks but he held her till she fell asleep. She awoke to an aching soreness inside and the smell of bacon cooking. He poked his head into the bedroom, "I hope you like eggs and bacon cause that's what we're having."

"Fine," she said getting out of bed, "but first I want to soak in a hot tub."

"Ok, I'll be in the kitchen."

At breakfast they talked of school then he said, "My parents are supposed to get back from Europe during vacation time. Then you can meet them."

She smiled, "Then you can meet mine too."

The next day they left for the drive back to the campus. Brana snuggled under Devon's free arm and hummed along to radio music. When she got back to her Dorm her roommate Susan was there.

"Hi, so what happened? Did he propose? Did you make love? Tell me, tell me."

Brana laughed then sat down on her bed with a wistful expression but said nothing.

"Oh really?" Susan said, "Well, I don't believe a word of it and furthermore the first time I had sex with a boy it was icky. Was yours icky?" She paused but Brana was still quiet so she looked heavenward, "How come I got stuck with an Encyclopedia of Silence!"

"I'm engaged," Brana said showing her the ring.

"Really," Susan's eyes widened, "and you didn't have to go thru icky?"

Brana sighed, then with mock sophistication said, "Oh Susan, you're so immature."

Susan fell back on the couch and laughed, "Yes, Mother Superior."

Hedy got Brana's letter a week before school ended for Christmas vacation but when she read Brana was bringing home her fiancé she wasn't happy. At 18, Brana needed to finish college then she wondered what the new beau was studying. Brana was not one to give information freely. She was a quiet child and actually took after her father. Then Hedy looked into a mirror and saw her husband standing behind her.

"Don't worry; you still look beautiful," he smiled. "Why don't you accept that TV cameo if you want to work again?"

"Television is too harsh on a woman over 40. I should return to the Cinema." She looked at him. "I suppose I'll have to now that you seem to be retiring."

He bristled, "I'd have more patients if you wouldn't bother me so much at the office."

She ignored that saying, "I think I'll call Beldin tomorrow."

He looked frustrated, "How is it you seem to hear only what you want to?"

She walked out of the room and returned to her first love, the mirror in her bedroom. She wondered why do they think an actress is too old when she's in her 40's? She was really just coming into her prime.

Hedy called Beldin, "How are you?" he sounded apprehensive.

"Myer, I want to work again."

There was a pause then, "Didn't you get the stock I sent you?"

"I got that nearly worthless paper."

"Well," he said, "pictures aren't what they used to be. Television has cut into our profits. And you've been out of the limelight for a decade and the new generation doesn't know you."

"Then I'll get some publicity and they will know me. Find me a good script. I'm coming back next month."

"But Hedy, that's not enough time. Don't do this to me. I'm an old man now and my heart's not too good."

She paid no attention to that. "Myer I don't want to hear excuses." She hung up.

The day Brana arrived Hedy was decorating a Christmas tree. "Oh, my baby's home," she gushed throwing her arms around her daughter.

Brana kissed her mother's cheek, "Hello mother, you look lovely and so does your decoration. I wondered may I invite Devon over for dinner, tonight?"

"Who?"

"The boy I'm engaged to."

"Oh, yes fine, but I think you're too young to be engaged. You must finish college."

"I will but can I invite him? See my ring."

Hedy looked at the diamond and sighed, "Alright, I'll tell the cook. But what is this boy going to be?"

"He's studying to be a Psychiatrist."

Hedy did not look thrilled, "Well, I'm sure your step-father will be happy to hear that."

That night at dinner Hedy tried to draw information out of Devon. "So what does your father do?"

"He's in the import, export business and travels to Europe but when he's home my parents attend a lot of social functions."

"Really," Hedy said, "and do you get invited?"

Brana looked slightly embarrassed at that question and answered for him, "Devon spent a lot of his life at boarding schools like I did."

Samual cut in, "Devon, more roast beef?" He handed Devon a plate and the two men smiled at each other. "I think you'll find Psychiatry a good field to enter."

After that Hedy said very little for the rest of the evening.

When Devon had left and Brana gone to bed Samual said to Hedy, "Let her find her own way. Don't try to direct her life now."

"Whatever are you talking about," she said as they walked to their bedroom. "It's a mother's responsibility to teach her daughter the right way."

"Hedy, it's too late to teach her your way of thinking now." He went to the bathroom and turned on the shower, got in and thought about his marriage. He felt defeat and frustration. How

do you give to a woman who feels it's never enough? He couldn't seem to communicate with his own wife. The marriage was a mistake but even psychiatrists make mistakes of the heart.

Devon's father was in the library examining a volumn of Beardsley when Devon walked in. "Dad, Brana is really a fantastic girl and I want to marry her. When can I bring her over?"

"Hmmm," his father seemed to be examining small print with a magnifying glass.

"You don't seem interested in meeting her so I thought you should know I bought her a diamond engagement ring."

"What?" his father looked up frowning.

"You know, I told you her mother used to be a movie star named Hedy."

"Yes, I remember her but son you don't want to marry a girl coming from those Hollywood scandals. Her mother was a notorious sex symbol and I heard her father was some effete gigolo with a fake title. But I understand, son," he slapped Devon on the back, "Have your fun but if you're going to be a doctor you'll need a respectable wife.
Now your mother and I met a high society debutante in Europe with legitimate wealth and genuine aristocracy in her family. A fine girl you can meet during your summer vacation."

"But Dad, I love Brana."

"You could always have her on the side as your mistress," he winked. "Wives keep the world going but mistresses keep it spinning." He turned back to his book.

Devon felt depressed but said no more and went to his room. The next night he took Brana to a movie but didn't mention his parents were back. Maybe in time his father would see he was serious; maybe by summer.

When Brana asked about them he said, "I don't think they're coming back this holiday. Sometimes Dad gets hung up on business."

Brana nodded, "Oh, well, mother's going to Hollywood next summer. I thought you could come visit me there. I'm sorry I didn't get to meet your parents."

He shrugged, "I doubt you'd enjoy meeting two stuffy snobs anyway."

Brana suddenly shivered, "When do you think I'll meet them?"

"Oh, probably next semester if you're unlucky"he laughed.

His casual attitude bothered her but she said nothing.

Chapter 21

FORTUNE

Fortune may have better success for you.
They who lose today may win tomorrow.
Cervantes 1616

It had taken Hedy a little longer than a month to return to Hollywood but it was too soon for Beldin. She was sitting across from him in his office.

"But Hedy, when you left Hollywood it was because your last film wasn't a big success and you said you wanted to retire anyway."

"That was then and this is now. I made a successful film for Anak in Europe but because of the moral code here it was never seen. Besides it takes more money to live these days, I can't stay retired."

Beldin sighed, "Did you know the FBI investigated you because of Gunther?"

"Really, well I'm more patriotic than they are. I gave this government a great invention but they were too stupid to use it."

"They won the war without it."

She ignored that saying, "Now what kind of script have you found for me?"

"I haven't found one yet but you'll need publicity."

"I'll get some. Who's your publicity department working on now?"

"Charles Ballad. He's just finishing a film for us and Jacey is planning a party. She's still the social butterfly although her wings are drooping a bit."

"What's her phone number," Hedy asked thoughtfully.

"Jacey was delighted to hear from Hedy. "Darling, what's been happening with you? We'll have to get together. Charles is just finishing a film and I'm planning on having a party for him at a new private club called Benitos. Would you like to come? I'm sure Charles would love it."

"Yes, thank you." Hedy wanted that invitation as she knew the press would be there. She would have to plan her entrance with care.

Charles Ballad thought Hollywood had grown accustomed to bizarre antics by balmy actresses but none got as much coverage as Hedy did upon her entrance to his party.

With sirens wailing and bells clanging Hedy was chauffeured through the crowd of press riding on top of a bright, red fire engine. She waited a few minutes for the stunned photographers to man their cameras then she alighted wearing a low-cut red satin gown that slithered down her body to her ankles and a red fox boa enveloped her shoulders. She smiled, waved and stood patiently for as many pictures as possible.

One reporter asked, "Aren't you Hedy ?"

"Yes," she smiled at the recognition.

"My God, I covered your yacht wedding years ago. You were inventive then and it's nice to see you haven't changed."

"Thank you. I'm back to do a film at Beldin Studios but I can't talk about it yet."

The sirens and commotion had brought half the party to the entrance. "Hedy!" Jacey yelled, "That's marvelous. You can't beat an entrance like yours." Jacey laughed pulling Hedy by the hand. "Come inside, Charles is waiting."

A young reporter stared after the two women as they went through the door then he asked the photographer who talked to

Hedy, "Who was that?"

"That, my young friend, is a legend named Hedy . She's still beautiful and I remember when she first appeared on the screen. She really moved the audience and not just with acting." He winked and walked away.

Once inside Hedy got the kind of attention that was like a shot of adrenalin for her. "Hedy," Charles Ballad kissed her cheek, "how nice to see you again. Let me introduce you to some friends."

At that moment Nord caught sight of Hedy and said to Philip, "Guess who just slithered in; The little marriage counselor herself."

Philip turned to stare at Hedy. From a distance she looked like she hadn't aged at all then he said, "I need to talk to her about Brana."

Hedy was being introduced to a young man, "This is Studan Demoine," Charles was saying, "he's from France and aspires to being an actor."

Studan was handsome with tea colored skin and oriental eyes, an exotic look that could only come from a mixture of many races.

"Have you been here long?" Hedy asked.

"Long enough to get discouraged," he sighed.

"Hello Hedy," she heard Philip's voice behind her.

She turned to see him and Nord. "Hello Philip," she nodded to Nord. "I see your marriage lasted longer than most Hollywood couples."

He gave a sigh of relief. At least she wasn't hostile. "You're looking lovely as ever," he smiled.

She thought time had etched laugh lines on his face but

how could his face reflect happiness living the way he does?

The orchestra started playing, "My Heart Cries for You" and Philip asked, "Would you dance with me for old times sake?"

She nodded and they glided onto the dance floor. Nord was standing next to Studan, "Old songs are boring."

"I love them. My whole repertoire is nostalgia."

"Really, then you'll love Hedy," Nord said sarcastically.

"I haven't much time for women while I'm concentrating on my career."

Nord raised his eyebrows, "Oh a little short on funds? Maybe Hedy could help your career, she used to be a big star."

Then they both turned to look at the dancing couple as Philip asked, "How's our daughter doing?"

"Oh she's going thru a school girl crush but she's healthy."

"Good, I'd like to see her."

The music stopped and Hedy didn't answer as they walked back to Nord.

"So Hedy, is your visit business or pleasure," Nord asked. "Both."

The music began again with the band playing Glenn Miller's 1941 hit, "String of Pearls." Hedy could tell Nord didn't want Philip dancing with her again so she took his arm saying, "Let's have another dance for old times sake."

Philip looked surprised but readily danced off with her. Nord sighed and looked at Studan. "Why don't you cut in and show her you've got style." Nord must have said the right thing because Studan walked onto the dance floor and tapped Philip's shoulder. Now both Philip and Hedy were surprised but Philip graciously bowed and returned to Nord. Hedy was pleased that Philip could see she was desired by a younger man.

Philip returned to Nord saying, "It's a shame that after

all these years she hasn't changed much. It seems she's been assaulted but never touched. I wonder what it takes to reach her?"

Nord sneered, "She may get lucky tonight but not with you."

Hedy stayed only long enough to see and be seen then she kissed Studan's cheek saying, "Another time, another place."

"Oh please, let me take you home," he begged.

She stared at him a moment then said, "I'm married but my husbands out of town for a week."

"I'll be your husband for a week," he grinned.

"Charming," she said taking his arm and they walked thru the crowd and made their exit into a fire engine while flashbulbs photographed them.

When they returned to her Bel Air mansion there was a package postmarked Greece. She picked it up and they walked into the living room. "Fix yourself a drink and fix me a Martini. I'll be right back."

She went immediately to her bedroom and opened the package. A reel of film with a note attached. 'Dear Hedy, I heard you returned to the scene of the crime so I thought perhaps your sense of humor might be ready to watch this film now. Please accept it with the spirit in which it was made. Much Love, Anak.'

Finally he had the decency to send it to her. She threw it on the bed, took her coat off and went back to the living room. Studan handed her a Martini, "Tell me some exciting stories from your film career."

She smiled, "Let's talk about you, what are your plans?"

"To become a star," he answered immodestly. "I sing, dance and act, I just haven't been discovered yet."

She sipped her Martini and a warm glow enveloped her. She wasn't sure what she wanted to do with him. "Do you like my gown?" she asked.

"I like what's in it better," he grinned.

"I like a man's opinion of my clothes. I bought some bathing suits yesterday. Come upstairs and tell me what you think."

He took his drink and followed her into the bedroom. "What's this?" he asked picking up the film.

"A stag film a friend sent me," she said unzipping her gown.

"Really, I love stag films, they really stimulate me."

"Hmm," she said debating with herself. He had piqued her libido but apparently he needed more than a fashion show. "There's a projector in the closet if you really want to see it."

She decided not to try on bathing suits but instead went into the bathroom and came out wearing a filmy, gold negligee. He had the film running on the wall so she sat on the bed and began watching herself with as much avid attention as he was. She had expected the film to upset her but instead it aroused her. She moved closer to Studan and began running her fingers up his arm.

He grinned and said, "Scratch, scratch me back. That's Jamaican Patois." Then still watching the film he said, "Hey, that Harem looks like a thousand and one nights of fun."

"It was only one night," she whispered running her hand over his groin. He then turned to concentrate more on her.

Hedy didn't awaken until noon. Her date was still sleeping. She rolled out of bed and stared at him. Just like a young boy, no control. He really needed to be taught by a mature woman but she wasn't looking for a teacher's job. She went to the bathroom and returned freshened in a white feathered dressing gown and rubbed his head to awaken him.

He stirred, opened his eyes and groaned.

"Hello," she said, "It's a beautiful day. You should go buy

me a diamond necklace to say Thank You."

He blinked, "You got things turned around. I was told you is the John and I is the Trick."

Hedy frowned, "I don't understand your Jamaican Patois but I have a business meeting at the studio today. Do you want to escort me?"

"Yes," he jumped out of bed and ran to the bathroom.

She stared after him thinking he might be the youthful image she needed now. Maybe if Beldin sees she attracts the younger set he'll be more inclined to offer her a film. Perhaps she could use him after all.

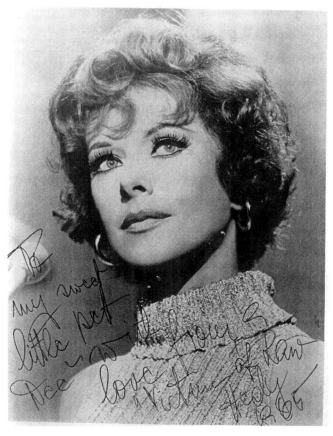

HEDY MAKES A COMEBACK

Chapter 22

MISTAKES MAKE DISCOVERY

*He who never made a mistake,
never made a discovery*

Beldin looked distressed when Hedy walked into his office. He hadn't slept well and he already had indigestion from breakfast. The moment he saw Hedy he took another heartburn pill. Then he adorned his faded face with a hollow smile saying, "Hello, my dear, how are you?"

Hedy nodded then spread the open morning paper across his desk. "How's this for publicity?"

He looked at the picture of Hedy alighting from the fire engine. "Very clever. Did you hire a publicity agent?"

"I hired myself. I'm all you need to make a successful film."

Studan who was standing next to her extended his hand, "I'm Studan Demoine. I sang at a B'nai B'rith benefit you attended last year."

Beldin coughed, "Yes, well Hedy a few more publicity items like this and we'll talk business."

"We'll talk business right now," She said sitting down. "I want to start work on a new picture next month and you're going to find me the right one. The budget should be around five million."

Beldin choked on that number then said, "Surely you jest."

"You're the one who told me I have no sense of humor." She stared directly into his eyes. "I know you understand me."

He began to turn red. "Don't do this to me, it's impossible, too much stress. You'll ruin the studio. No, I won't be put under this pressure." He slammed his fist hard on the desk.

She calmly said, "You'll do it. You don't want adverse publicity at your age. Think of your grandchildren."

He was shaking his head so hard the veins bulged in his neck. Then he began choking.

"Don't get yourself so upset," she feigned concern. "Rest now and we'll talk again tomorrow. Come," she motioned to Studan as she strode out of the office without a backward glance.

Beldin was gasping for air then he suddenly clutched his chest and slumped over on his desk. But Hedy was already in the outer office talking to Mary when she heard Studan yell, "Hedy."

She was perturbed he didn't follow her out. The boy didn't know how to make an exit. Then Studan was in the doorway looking bewildered, "He's turning blue!"

Mary ran to Beldin and screamed, "Call an ambulance!"

Hedy walked back into the office as Mary looked up, "I think he's dead!"

"Dead?" Hedy shook her head, "How dare he die now!"

Mary was dialing for help. Hedy thought a moment then went back to Mary's desk and called a newspaper. She was thinking I'll tell a reporter it happened right before my eyes while we were planning another epic film for my comeback. Perhaps she could influence the Board of Directors that they must continue where Beldin left off. Suddenly she had the feeling she would get publicity and a picture. How ironic that once again Beldin had become valuable to her through death.

It was a hot June day and Hedy was studying her new script. A horror film wasn't exactly what she wanted but it was

what the Board agreed to do. She wondered why the public liked horror films? Life was scary enough without watching it on screen. Well at least she would be the beautiful leading lady again. The phone rang. It was her husband saying he would be back from New York tomorrow.

"Fine," she said and hung up thinking it was good she hadn't continued her friendship with Studan.

Then the phone rang again. "Brana dear, how nice to hear from you. Oh I don't know they didn't give me the script or the budget I wanted. It's one of those awful horror things."

"That's great," Brana said. "They're very popular now. I've sure been reading a lot about you. But too bad Beldin had to die. Did you know the papers here gave your whole life history with his studio? All my friends are talking about you."

Hedy was instantly apprehensive, "They are? What are they saying?"

"Wild things, they think you're far out."

"What does that mean," Hedy asked, "oh never mind. How are you getting along with your boyfriend?"

Brana sighed heavily, "I don't know really. He was supposed to introduce me to his parents but for some reason he seems to be stalling."

"Stalling? Well you come out here for awhile and let him miss you."

"I hate to leave Devon but maybe I should."

"Of course you should. Show a little independence. He'll want you more."

"Alright, I'll see you next week."

After Hedy hung up she felt restless and decided to go for a drive down Beverly Boulevard. She noticed a Ferris Wheel in

a children's park as she got closer she heard the carousel music. The amusement park gaiety enticed her to park and walk around. She wanted to ride the Merry-Go-Round but with all the little kids on it she felt foolish and bought some cotton candy then sat on a bench. As she stared at the colorful Carousel she got an idea. A Carousel would be a lovely way to get publicity.

She walked over to the ticket taker and said, "I'd like to buy that Carousel."

"You can't buy that Carousel, lady, it's not for sale."

Another man stepped up, "Perhaps I can help. I'm the manager."

Hedy arranged to rent a smaller Carousel and it would be delivered to her backyard in two weeks. How marvelous she thought on the drive back home. Something for fun that will cause a sensation with the press.

The day Brana arrived Hedy was doing exercises with a physical therapist. A handsome young man she had met at the studio beauty parlor. Hedy was standing on her head with the young man holding her legs steady when Brana walked in,"Hi Mother, don't get down. I'll put my things in an empty bedroom."

"Let me help," the young man said then told Hedy that was enough exercise for the day. He grabbed one of Brana's suitcases, "My name's Al, I've been helping your mother get in shape for her new film.

"How nice," Brana smiled and he followed her into a bedroom. "Just put the bags on the floor. Thank you."

He set the suitcases down then asked, "How long are you going to be in town?"

"I suppose till I go back to school or get deported," she laughed.

He smiled, "Maybe I could take you to dinner some night."

He was nice and she was depressed, "Maybe."

"Great, I'll call you in a couple of days."

Samual was walking in as Al was leaving. They waved at each other and Samual went to fix himself a cocktail. Hedy walked over to the bar, "So did you cure any crazy people today?"

He laughed, "People are crazier than ever with this Viet Nam war. They don't believe in this government anymore. I'm trying to get people who don't believe in anything to believe in themselves and to be the change they want to see in this world. But listen, tell the cook to take the night off and I'll take you and Brana out for dinner."

The next day the Carousel was delivered. Hedy had two reporters and a photographer waiting. She smiled and posed next to a gold horse saying, "Yes, it's necessary for my work. I memorize lines better when I ride a Carousel. My new film starts next week and I'm going to talk to the director about using this in a scene."

Samual and Brana sat on porch chairs watching the proceedings. Brana said, "Mother sure knows how to get publicity."

Samual smiled at her, "Yes, in one short month she pushed her way back into pictures, got a starring role and killed off the head of the studio. Even for her that's a record."

Brana looked surprised, "Are you sorry you married mother?"

"No, at the time she needed my help and I loved her enough to give it."

"Loved?" Brana questioned the past tense just as Hedy walked over followed by her entourage.

One photographer asked, "May we have a picture of all of you together?"

"Sure," Brana answered but at that moment she felt like a total stranger and wondered if Samual felt that way too. Still she posed and smiled then wondered what Devon was doing. What was wrong with him lately? Perhaps she should call him. She got up saying, "I have to make a phone call."

Hastily she dialed his home number and after a few rings she heard, "Hello."

"Devon, it's Brana."

"Brana, where are you? I mean I know you're in California but you didn't leave your number."

"Oh," she said then gave him the number and address. "Are your parent's home?"

"Not right now. What are you doing?"

"Well," she laughed, "you could say I'm going around in circles. Mother got a Merry-Go-Round for the backyard."

"Sounds like fun but when are you coming back?"

"When do you want me back?"

"Yesterday."

"Really, did you tell your parents about me yet?"

"Actually they've known about you for awhile, it's just that they're busy."

"I don't believe you," she half cried. "I know something's wrong and you won't tell me. Well when you're ready to tell me the truth you can call or come out here." She hung up.

He heard the click and muttered, "Oh hell." She was right, something was wrong with his father. He would just have to go to California and tell her the truth.

Even though Hedy wanted to work she was two hours late

on the first day of shooting. She might not have gotten there at all except that Samual reassured her she looked fine and drove her to the studio.

She knew her lines perfectly, yet when it was time to face the camera she couldn't remember them. But the director was understanding and had her sit on the sidelines watching a scene she wasn't in so she could get the feel of it again. When finally she decided to do it she was like a tiger making demands, directing scenes, changing lines and disapproving camera angles.

"Take a break," the director yelled after an actor playing opposite Hedy flubbed his line five times.

The director turned to his assistant, "She's intimidating the other actors." He sighed, "I'll have to have a heart to heart with her."

Hedy had her back to the door when the director knocked and came in to her dressing room. She listened but pretended to be fixing a bracelet and didn't look at him. "You see Hedy, picture making is different now. We're under money and time pressure because of television. We can't afford to make movies the way they did in the '40s. So if you could be punctual and not change the script it would be a big help to all of us."

Hedy leveled her eyes on him as if she were sighting a target through a gun barrel. "I know more about acting, directing and writing than you'll ever learn. People pay to see me! I'm a star and I know how to act like one. Now see if you can get your amateurs to stop doing retakes."

The directors face turned red, "I hope you realize you're digging your own grave with a 1940 shovel!"

If an observer thought things were tense the first week he would have thought they were a spent tranquilizer by the end of

the second week. Everyone seemed to be screaming at each other except Hedy, she watched calmly while the fuse she lit burned towards the powder keg.

"Thank God it's Friday," the script girl sighed on her way out.

But before going home Hedy ordered a screening of the rushes and wasn't happy with the way she looked. Who was that mature woman on the screen? It must be the lighting or the makeup. Damn this new Hollywood with its stupid realism. Didn't they understand that audiences don't want reality they just want to be entertained.

When she walked through her front door that night she felt like talking but Brana was on her way out. "Hi Mother, you look like the first reel of a hurricane scene. You must have had a rough day." She laughed.

Hedy was not amused, "Where's Samual?"

"He had a business dinner and said he'd be home late. And I'm tired of waiting for Devon to call so I'm going out with Al." She quickly kissed her mother's cheek and was gone.

"Al?" Hedy thought, "My personal trainer? She looked at the closed door then walked to her open bar. The bar refrigerator had three bottles of chilled Champagne. She popped the cork on the first one and it squirted up like a golden shower. There was something sexual about Champagne she thought as she poured herself a large Brandy snifter full then went to change into a beige peignoir that was cool and comfortable for the hot cotton candy night. In the mirror she could see her nude body through the filmy material. Her breasts were lower but still looked good. She drank the Champagne and went for a refill. The refill emptied the bottle so she opened another and took it out to the patio.

It was one of those Navy Blue summer nights and not a
palm leaf moved. The pool water looked like glass. Where was
Samual when she needed him? Hell, where was he for the last
two years. She walked to the Carousel, sat down on a red painted
bench then leaned over and flipped the switch on. The drum
boomed, the music began and she leaned back to enjoy the ride
while sipping her Champagne.

She didn't hear the doorbell or the knocking on the side
gate and even when she saw Devon walking towards her he
looked like a mirage as she whirled by. He jumped on and came to
sit next to her.

"Good evening. I heard the music and thought Brana might
be here."

"Brana is out on a date."

"A date?"

"Yes, did you think she would sit around and pine away
for you?"

"Well, ah, we are engaged."

"Really, then why is she so unhappy?"

Devon slumped back tired. He had come directly from the
airport and eaten nothing. He had smoked some Marijuana on the
drive over in his rented car and now the circling ride made him
slightly dizzy. "Could I have a drink?" he asked.

She handed him her glass and he finished it. Pot always
made his mouth dry.
Hedy grabbed the glass back and emptied the second bottle of
Champagne into it. She had not eaten and now she was drunk. She
threw the bottle into the bushes laughing, "Let the gardener figure
that one out."

Hedy's Jungle Gardenia perfume enveloped Devon and
suddenly she was out of focus and it was Brana. Brana invitingly

naked as the peignoir opened to the breeze like a filmy cloud billowing away as he reached for her. His body was burning as he unzipped his pants and in a moment was inside her. The pounding in his head was as loud as the Carousel drum pushing a pulsing rhythm through his body into hers. The pounding drum, the ear shattering crescendo of cymbals and Hedy was at her peak, desired and loved by a younger man again. Then the crucifying crescendo of relief and Devon fell back to reality. A wave of nausea passed through him and he jumped off twisting his ankle as he rolled over on the lawn. Then the vulgar truth sweated out of him and he retched over and over until there was nothing left.

Hedy stopped the Carousel and leaned over the bench staring at him. He glanced at her as he stumbled to his feet and cried out, "No, I didn't, it was your fault. My father was right!" Then he ran stumbling out the side gate.

Hedy stared after him dazed by the experience she just had. Samual drove up and saw Devon speed away. He walked into the house and found Hedy behind the bar opening the last bottle of Champagne.

"Wasn't that Devon that just left?" he asked noticing how disheveled she looked with a half open negligee. He stared at her thoughtfully, "Did you do it again? Did you ruin another life?"

"What the hell are you talking about?" she frowned.

"Hedy, if you did what I think you did then you committed your worst sin ever! A sin against the flesh of your flesh!"

Don't give me your psycho crap," she lashed back irritated.

He shook his head, "You poor emotional cripple. The one time you might have done something noble and you failed miserably."

"Shut up! Get out! I don't need you!"

He continued, "If you had any strength of character you could have encouraged the boys' affection for Brana. But no, you're still playing the femme fatale." He sighed heavily and reached for a Scotch bottle pouring himself a full glass and drinking it down. He turned back to her, "Haven't you any guilt? There might be some hope if you felt guilt."

She sneered at him, "You need a psychiatrist!" Then she turned to look in the bar mirror.

"What do you see, Hedy?

She whirled around, "I said get out! I'll file for divorce tomorrow."

"That's right, follow your pattern." He shook his head, "Chew them up, spit them out, they'll always be another jackass around to marry you. But for what now, your fame, your fortune? I think you've seen the last of love!" He took the Scotch bottle and left.

Chapter 23

SIN

*Sin has many tools but a lie is
the handle that fits them all!*

"This end of the picture party is more like a thank God it's over party," the director was talking to one of the actors in Hedy's film.

"Yea," the actor nodded, "this really was a horror film. But I hear she's going to make up for it by having a Hollywood party like the good old days at her place."

Hedy had hired Jacey Ballad's caterer and the Ballad's were among the first to arrive. Then people came in droves.

"Wow, mother, half the town must be here," Brana said jostled by the crowd.

"More than I invited," Hedy was looking around. "But put something on the stereo besides that Twist music."

She saw Tita Harris and waved then she spotted Philip and Nord and a few bobbing heads behind them she was surprised to see Jack Byer and Gentry.

Tita came over to Hedy, "Well darling, this may prove to be one of the better Circuses I've been to lately."

Hedy nodded, "Yes, I'm celebrating several things, the end of the picture, the end of my marriage and the end of my daughter's engagement."

Brana was standing close by and Tita noticed the surprised look on her face. Immediately Tita knew that Brana was unaware of her broken engagement. She turned back to Hedy, "Well should I say congratulations or I'm sorry?"

"Just write a nice story about my film and this party,"

Hedy smiled then greeted another guest.

Jacey Ballad also heard what the two women said and went over to Brana, "From the surprised look on your face I'd say you just learned about your broken engagement. But don't worry, you're young and they'll be plenty more chasing after you."

Brana shook her head and rushed out of the room. Jacey wanted to help but how?

Then she noticed Samual walk in and went over to him, "Hello Doctor, how are you?"

"I'm crashing this party but I'm surviving being thrown out."

"Yes, I just heard about your divorce. Do you need a good psychiatrist," she laughed trying to keep it light.

"I need a friend," he sighed.

"Listen," Jacey lowered her voice a little, "so does your stepdaughter. Hedy said her engagement was over and I think it was the first she heard about it. Do you think she might do something foolish?"

He looked worried, "I'll see if I can find her."

He found Brana crying in her room. When she saw him she asked, "Did you know?"

Samual nodded.

"But why didn't she tell me?"

"Perhaps she was waiting for the right time."

"When would that be, when I read it in the papers?" She took a deep breath. "I don't want to go back to school. I don't ever want to see Devon again."

He patted her arm, "I know you don't believe me now but you'll fall in love again. There's plenty of time for you." He looked away and softly said, "That's what I keep telling myself."

She realized how he must feel, "I'm sorry about the divorce."

"Well, when you're my age you become philosophical about life and love. You learn that love doesn't mean security and kisses are not contracts. But with your head up you learn to build all your roads on today because tomorrows ground is too uncertain. So plant your own garden instead of waiting for someone to bring you flowers. You really do have worth and you learn with every goodbye."

There was a knock on the door and Philip opened it, "Hi, I hope I'm not interrupting anything. I'm Philip Bolton, your father!" He looked directly at Brana.

She was stunned again but managed to say, "Come in, this is my stepfather, Samual."

The two men shook hands and there was an awkward moment before Samual said, "Well it's nice to meet you and I'm sure you and Brana have a lot to talk about so I'm going to get a drink before the party's over."

He had the door half open and stepped into the hall. Nord was leaning against the wall and said, "The party's been over for a long time but Hedy's clueless."

Samual laughed then walked to the bar.

Philip sat on the bed next to Brana, "I know you must think I'm a terrible father for not seeing you all these years but Hedy made it impossible."

Brana nodded and stared at her father. He was handsome, impeccably dressed and his eyes invoked pathos. He continued, "I know it's difficult for you to think of me as your father but think of me as a friend. If you ever need anything let me know and I'll try to help."

"Thank you," she said softly. "Right now I could use help, I don't know what to do with my future."

"Oh, what's wrong?"

"A broken engagement that I just found out about."

He patted her hand, "I won't say you're young and you'll get over it because everybody says that but," he pulled a card out of his pocket, "here's my card. You can call me anytime. If I'm not there leave a message."

"Thank you," she said with a sad smile, "I'm sorry I missed all those years of knowing you."

He smiled relieved, "Will you join the party and have a drink with me and my friend Nord who's also my business partner?"

She nodded and they stepped into the hall where Philip introduced Brana to Nord.

Then she said, "I really don't feel like being at a party."

"Don't worry," Nord laughed, "it's gotta end soon, they ran out of toilet paper!"

Philip poked Nord but he just laughed.

Across the room Hedy sat down exhausted next to Jacey, "My God, aren't they ever going to leave."

Jacey smiled, "You shouldn't have such fun parties. Now if you had your fire engine you could hose them out. But I'll get Charles and make a noticeable exit, maybe the others will follow." She kissed Hedy's cheek. "Thank you darling, I'll be calling."

Jacey saw her husband talking to Samual and as she walked over heard Samual say, "It's sad for Brana because first love never comes back quite the same again."

Jacey pulled at her husbands sleeve, "Hedy would like the party to end and we could help by leaving."

At that moment a gun shot startled the crowd. Hedy was standing on a table with a smoking gun that she had just fired thru an open window, "The party's over," she yelled and people left in droves.

Jacey said, "Well she makes dramatic entrances and exits!"

"What a party killer," Nord laughed.

Philip sighed and turned to Brana, "Your mother's always been overly dramatic."

Nord shook his head, "No, she's more like a Macy's sale, Half Off! Well come on my love." Nord pulled at Philip. The word love hit Brana like an electric shock. Jacey stared at her thinking, "This poor child is hearing it all tonight."

Before Jacey left she said, "Hello Brana, I'm Jacey, a friend of your mothers for a hundred years. You're so beautiful and lucky to have such talented parents."

"Thank you," Brana half smiled.

Philip said, "Good night, Brana, call me."

Brana stared after her father and his friend then she noticed Jacey still next to her. "Your father is a genius in interior design. George Sand once said, "The abstract of Genius has no sex. Which I never quite understood," she laughed.

Brana sighed, "I think I understand and thank you."

Jacey kissed Brana's cheek and so did Samual and they all left together. Once everyone was gone Hedy and Brana stood alone as Caterers began cleaning up. Brana looked at her mother and asked, "How did you know about my broken engagement?"

"Oh Devon, he called but I was so busy I forgot. But you can do better than that weak little boy. Just because he looks like a man doesn't mean he is."

Brana began to cry, "I think I'll kill myself."

"Don't be ridiculous," Hedy scoffed, "over a silly idiot who doesn't know what he wants."

Brana sobbed, "I'll leave a suicide note 'Cancel tomorrow, lack of interest!'"

"Puhleeze," Hedy sighed, "have I given you more credit than you deserve for common sense? You have your whole life ahead and don't depend on anyone else, YOU make it interesting!"

The next day Brana woke up depressed. She wandered around the house then decided to get away from Hedy so she went to the library and read books on love and philosophy. Then she called Philip. He invited her to his studio to see all the art work. When she arrived Philip showed her around and she was impressed. She looked at a painting of Cupid aiming his bow and arrow at a naked woman and she said, "I hope he misses."

He laughed, "That's good, you've got a sense of humor."

She sighed, "I hope so, I sure need one these days. The worst part is I don't know what went wrong with my relationship."

"Then it wasn't your fault," he tried to comfort her.

"Maybe you're right. The last few months Devon wasn't as close and then he talked to mother and it was all over."

Philip smiled and patted her shoulder, "Well, when your mother's involved, things often end in confusion. I remember when we went to court for our divorce she had both lawyers crazy and mine said to the judge, "Your honor, we're too young a country to cope with this woman."

Brana laughed, "But now I don't know what to do with my life?"

"Well, what do you want most in the world?"

She thought a moment, "Peace."

Nord walked over, "Me too." Philip threw him a shut-up look. Nord shrugged, "Well I like humanity, it's people I can't stand."

Brana smiled at him, "I think the kids today are fed up fighting wars. It just seems like everytime someone works for peace they get killed. Like that Swedish Ambassador who was on a peace mission and they shot his plane down."

Philip was surprised his daughter knew so much about world affairs, "I'm impressed by your knowledge but why don't you be the change you want to see in this world?"

Nord butted in, "You could join the Peace Corps."

"The Peace Corps?" Brana mulled that over in her mind.

Philip grimaced, "Hedy would never approve of that."

"Of course not," Nord said bluntly, "that's a giving job not a taking one."

Philip pushed him away, "Ok, you've helped enough. Come Brana I'll take you home."

Chapter 24

END OF THE ROPE

When you get to the end of your rope,
tie a knot and hang on!

"You did what?" Hedy shouted at Brana.

"I joined the Peace Corps. They're sending me to Africa."

Hedy swooned, "I'm going to faint." She slumped into a chair.

"It's only for two years."

"You've gone mad! That's a jungle for God's sake."

"Oh Mother, it'll be a great experience. Maybe I'll make a difference in the world and I can write about it. I'll be working with Nuns and Doctors and teaching children in the hospital."

Hedy shook her head, "There are lions, snakes, man-eating plants and God knows what diseases."

"My father likes the idea," Brana said softly.

"Your father is jealous. He's just trying to get you away from me."

"It's what I want to do right now. I might even get a chance to work with Dr. Schweitzer," Brana said wistfully.

"And who are you, Mother Teresa?"

"I'll learn a lot when they send me to Kenya for training. I already speak French so I'll be learning Swahili."

"Swahili? Nobody speaks that language."

"They do in Kenya, Tanzania and Uganda."

Hedy was shaking her head, "Just like your father," she said walking out of the room.

Brana sighed and went back to reading her training

literature. For the first time in nearly a year she felt content.

Three weeks later Philip woke up to hear Nord laughing, "Hedy's done it again!"

Philip frowned, rubbed sleep out of his eyes and looked at the clock. Seven was too early for him but Nord was already up and reading the papers.

Philip yawned, "What now?"

"Well, you know how the critics panned her horror film, they said it was a fright and she was a horror."

Philip nodded and Nord continued, "Her director had a press party and Hedy showed up doing her fire engine bit but as she was leaving she turned the hoses on a bunch of critics and swept Tita Harris out the door and into the pool.

Philip was aghast, "Oh My God, she'll never work in this town again."

"Who cares? She should have stayed retired. She knows her career is over so she washed it away and went out with a big splash."

"I've got to get some tea," Philip said walking to the kitchen and coming back a few minutes later. "I think she just did it for publicity. I wonder what she'll do next?"

"Probably put a sign on her front lawn saying; "Church of the Unloved. Bring me your sick and depraved and I'll throw away your sick and swing with your depraved!"

Philip laughed, "I wonder if Brana will hear about this in Africa?"

"Why not? Africa has newspapers too but someone should tell her the law of psychic energy. If you expend yourself in negative ways you get it back in negative ways."

Philip nodded, "Too bad she can't fall in love, probably because she's had too much sex."

"And fame and money," then Nord added, "probably the only way to satisfy her now is an eggbeater with a French tickler on it."

Philip cracked up, "How do you think up such things? I'm glad Brana didn't hear that."

"Hey, Brana's a great kid, she's going to be a great woman. Look how she's trying to make the world a better place. Working in an African family planning clinic makes her a true humanitarian. Hedy could take lessons from her."

Two weeks later Brana read the item in the Kenya Gazette. Oh Lord, Brana thought, now she would probably get a letter from Hedy complaining how unappreciated she is in the movie business. She could almost hear her mother's words saying, "I'm a Pearl cast before Swine."

Brana put the paper down and looked out the clinic's window. She admired the magnificent cloud formation high above the smokey purple Kilimanjaro Mountain. Opening the window she inhaled the exhilarating clean air. In the distance she saw some Masai approaching. The Masai were primitive people and most came to the clinic nearly naked except for flies stuck to their skin because of the vile ointment they rubbed on their bodies to keep wild animals away. The natives came for medical care but sometimes you could talk to them about birth control. The doctors would probably be needing her now.

There were two doctors, Dr. Zelski from Poland and Dr. Tomoff from Russia. Dr. Zelski was tireless in his efforts to teach the natives family planning but it was an uphill struggle against old traditions. In Kenya a mans success was measured by the number of children he had. Daughters brought dowries and sons were good workers. But the population had doubled in the last ten

years and the disastrous results were famines, disease and tribal wars.

Brana walked into Dr. Zelski's office and he looked up from a letter he was reading. "Ah Brana, we will be getting a new volunteer tomorrow; Ziva Sael from Israel. You'll finally have some help."

"That would be nice."

"Yes, and she's about your age so hopefully you'll have a friend. In the meantime, could you talk to that native woman about birth control."

Brana nodded and went back to work. That evening she wearily went home to her small apartment. She didn't have television so she either read or thought about Devon and wondered if he'd found a new girl friend. Oh well, she reminded herself, don't look back you're not going that way.

She was up early the next morning, took a Malaria pill and prepared for work. On her way out she noticed something in her mail slot. A letter from Hedy. She tore it open and read while she walked to the Clinic. Hedy was in New York auditioning for a play. She lauded the legitimate theatre and yet sounded vague about it but mentioned she had done a Aspirin commercial. Brana smiled thinking that was appropriate for someone who gives everybody headaches. Hedy wished Brana would come home to civilization and signed off with much love.

Brana took a deep breath and looked skyward. It would probably rain in about an hour and that was like a refreshing shower for the air. Near the Clinic she saw Zebras running across the plain, then she walked into the Clinic.

She hung up her coat, put on a white smock and went to the front desk. An attractive, dark haired girl stood next to Dr.

Zelski. The doctor looked up, "Oh Brana, this is Ziva Sael. She'll be working with you. She's also a Nurse and got her training in the Israeli Army Medical Corps."

Ziva had a beautiful smile and full lips with Café au Lait skin. Her large dark eyes were almost hypnotic and Brana felt a charismatic, ethereal sensation sweep over her and smiled, "Welcome. I'm Brana."

"Show her around," Dr Zelski said, "I have a patient waiting."

"Did you just get here?" Brana asked as they walked down the hall.

"Yesterday, I'm at a hotel until I can find something better."

"How long did you sign up to stay here?"

"Two years. How long have you been here?"

"Only a few months but I also signed up for two years. You can hang your coat here and take one of those smocks."

"These white smocks make us look like doctors but I think they give the natives a sense of security."

Ziva smiled and glanced into a wall mirror brushing her short, curly hair back. "I'm ready, where's the first victim?"

Brana laughed and knew she was going to enjoy this friendship.

The next few weeks were hectic. Besides the local natives they had a Safari come through. An American had fallen off his horse and broken a leg. The White Hunter brought him in.

"Hello, I'm Wendall Jerome. My client has a little problem for your Clinic." He smiled and Brana thought what a handsome older man. His tanned face was framed by grey hair and his strong features looked like a Greek sculpture. While he waited for his

client he talked with Brana. "You're American aren't you?"

"Yes, I was born in Los Angeles but raised all over the world."

"I'm a world traveler too," he smiled. "At this time in my life I'm traveling through this world so I'll probably be seeing you again. I come through every couple of months with my Safari's."

"Safari's must be exciting," Brana said.

"Frankly I'm about ready to retire. I wouldn't be working now except my wife has expensive taste."

Brana grinned, "Doesn't every wife?"

"Yes, but actresses are worse."

"Your wife's an actress, what's her name?"

"Tory Sontoug."

"I think I've heard my mother mention her. My mother's Hedy ."

"Oh, no wonder you look familiar. You're beautiful, like your mother. Are you working here now?

"Yes, it makes me feel like I'm accomplishing something worthwhile."

He nodded, "Kennedy sure brought back the patriotic spirit when he started the Peace Corps."

Ziva approached, "Hello." She nodded to Jerome then turned to Brana, "Time for a tea break. Want to join me?"

"Excuse me," Jerome said, "do you know how much longer the man I brought in will be?"

"About an hour," Ziva answered.

"Then may I invite you girls out for your tea break?"

"Mr. Jerome knows my mother," Brana offered.

"Then let's go," Ziva said.

The three of them walked to a café a block away. After

they ordered Jerome said, "I just can't get over that Hedy's daughter is working in Africa. Hell, you could be a movie star yourself."

Brana shook her head, "I've no interest in pretending to be someone else."

Jerome smiled, "I thought all pretty girls wanted to be in pictures."

"Yes," Brana laughed, "up to the age of reason."

"Some people never reach that age," he winked then looked at Ziva. "Do you girls live together?"

Brana shook her head, "No but that might be a good idea."

The two girls looked at each other. "Sounds like a good idea to me too. Then we could get a bigger place."

"Fine," Jerome said, "I've done my good deed for the day."

When they returned to the Clinic Jerome's client was ready to leave. They left and Jerome said, "I'll be seeing you, Brana"

The next weekend Ziva and Brana went househunting. They found a cottage closer to the Clinic that had two bedrooms and a den so they decided to move in the following weekend.

To Brana's delight the first box Ziva unloaded were books. Brana picked one up and said, "The Story of Philosophy; pretty heavy reading."

"If you think that's heavy look at some of my other ones, "Caesar and Christ" and "The Age of Reason Begins."

Brana smiled, "And begins and begins with every new generation. Did you ever read Mark Twain's "Letters from the Earth?"

Ziva shook her head.

"It's very funny. How about "Love in the Western World?"

Ziva smiled, "Are you talking about love or sex?"

Brana sighed, "They're supposed to go together. But I guess it's a rare person who's blessed with both."

Ziva stared at her friend a moment then said, "Sounds like you weren't blessed with both? I was in love once but he was killed in the Israeli Army."

"I'm sorry, mine just rejected me."

"Then you're lucky not to have a foolish man like that. You're an intelligent, beautiful woman and if he couldn't see that he was blind."

"Thank you," Brana said wistfully.

During the next month Brana and Ziva worked in the Clinic and taught family planning to the locals. When Brana finished her nurses training she began to think seriously about becoming a doctor.

Later in the week Ziva waved a newspaper at Brana and said, "I see that one of your mothers old films is playing at the local theatre. Want to go to the movies tonight?"

"I wonder what she's doing now," Brana mused. "Her last letter said she was going to sue the producers of a film she did that never got released. Ok, let's go to the movies tonight. And now, back to Birth Control class."

That night after the movie the girls stopped at a small café for hot chocolate. Brana seemed depressed and Ziva asked, "What's wrong?"

"Oh, I was just thinking about my life."

Ziva smiled, "Really, that is depressing."

"Well, I don't want to be like my mother with a lot of marriages and no real love."

Ziva patted her hand, "Yes real love is rare but with your beauty and talent I'm sure it will find you."

Chapter 25
FIND THE BEAUTIFUL

We travel the world to find the beautiful but
unless we carry it with us we find it not!
Emerson

Brana woke up to the sweet smell of flowers outside her window and she sang out, "The flowers that bloom, tra la, tra la."

Ziva poked her head into Brana's bedroom, "What's that?"

"I said it's a beautiful morning."

"Yes, and breakfast is ready."

Brana walked into the kitchen holding a small book. "Listen to this. 'God conceived the world and that was poetry. He formed it and that was sculpture. He colored it and that was painting. He peopled it with living beings and that was the beginning of the divine, eternal drama.'"

"He should have peopled it with Loving beings!"

"Ok," Brana smiled, "but I know he peopled it with loving beings because I live with one."

"Thank you," Ziva smiled putting a plate of scrambled eggs in front of her. "Now finish your eggs or we're going to be late and the world will be overpopulated."

It was mid-morning and they had finished teaching their class when Brana heard a commotion outside. The front door burst open and more than a dozen natives rushed in. Some were carrying bloody bodies of children, others were bloodied themselves. Brana was stunned, she had never seen so much blood all at once.

Ziva went right into action, taking children from mothers and administering aid immediately as Drs. Zelski and Tomoff rushed to help others. Brana was administering first aid to a small

child and asked Dr. Tomoff, "What happened to these people?"

"Tribal warfare. When different tribes disagree the innocents get hurt too."

A woman staggered through the door with a child then she dropped dead at Brana's feet. Brana grabbed the screaming child and rushed it to Dr. Zelski. Soon there were so many, so much misery and death that Brana got tears in her eyes.

After two hours Brana went to the bathroom and heard a radio broadcast as she passed the doctor's office then she came back and sat down next to Ziva and listened to the Swahili language a woman was speaking. Ziva turned to Brana saying, "This is a woman well acquainted with grief. Her people are not stupid but their tribal religious superstitions live on to kill them."

Brana sighed, "Yes, just like the tribes that live in America and everywhere else in this world." Ziva looked surprised.

Brana began to cry, "I just heard on the radio that President Kennedy was assassinated. Oh Ziva, it was such a beautiful morning."

Ziva stared at Brana feeling great sadness for her and the whole world. By then everyone had been administered to and Dr. Zelski came back in the room and put his hand on Brana's shoulder. "I'm sorry, I tried everything for the child but I think she had lost her will to live."

Tears now welled up in Ziva's eyes and she nodded at Brana, "It was a beautiful morning."

When the girls went home that night they were too tired to talk and each went to their separate bedrooms. But Ziva couldn't sleep and went into the kitchen for some warm milk when she heard moaning in Brana's room. She opened the bedroom door and saw Brana tossing and turning like a body possessed in a nightmare.

"Brana," Ziva said softly touching her arm. Brana woke with a start perspiring and shaking, "Oh," she cried, "I must have been having a nightmare."

Ziva kissed her cheek and Brana grabbed her and held on, "Ziva, is God a madman? Does he bring us here just to torture and kill us?"

"Shhh," Ziva held Brana's head against her breast. "You did very well today. You saved lives and everything will be better in the morning."

Brana felt a peaceful euphoria and suddenly she and Ziva were a oneness with eternal life and Brana relaxed and fell into a deep sleep.

During the next several months Brana began studying to become a doctor. She assisted during operations and was fascinated beyond anything else she had ever experienced when she held life and death in her own hands. The whole field of medicine and surgery became her life and many weekends she studied medical books. On other weekends she and Ziva would act like tourists poking around street bazaars or wheeling around town on bicycles.

One day Ziva walked into the living room and saw Brana reading a letter. "It's a beautiful Saturday want to go for a walk?"

Brana looked up frowning, "My mother's coming for a visit. She isn't working and thinks a change of scenery will be good for her. She doesn't say how long she intends to stay, just that she will be arriving next Wednesday at noon."

"Well, I can sleep on the couch if you want her to have my bedroom."

"That's very kind of you but actually I have the double bed so you could sleep with me if you want."

Ziva shrugged, "Fine, if you don't mind but she may stay longer than you think since you're her only child and she's not married now."

That made Brana nervous, "I think I'll have a Vodka Tonic."

Chapter 26

ART OF LIFE

To affect the quality of the day
that is the art of life!
Thoreau 1862

Brana borrowed a hospital Jeep and promised to be back as soon as she delivered Hedy from the airport to her house. She waited at the gate when the large Jet landed and soon spotted Hedy wearing a bright, yellow linen suit with a broad brimmed hat to match.

As Hedy approached Brana took a deep breath and smiled, "Hello Mother." She kissed her cheek and grabbed a small hand suitcase from her.

"Hello dear," Hedy said sounding tired. "I have more luggage to get."

At the baggage counter Brana collected six suitcases and loaded them into the Jeep. There was barely enough room for Hedy to sit on the passenger side with one case under her feet and another in her lap. "My whole life is in these suitcases," Hedy said. "Couldn't you have picked me up in a air-conditioned limousine?"

Brana laughed, "There are none at the Clinic but I didn't think you'd want to be picked up in an Ambulance."

Hedy was struggling with her lap luggage, "I'm going to need one after this."

Finally she settled back for the ride. It was a hot African day. "Is it always hot here?"

"Sometimes but often it cools off with an afternoon shower, so just relax and we'll be home shortly."

Hedy held one hand over her suitcase and the other over her hat as they bounced along the road. She pushed her hat down to shade her eyes and saw Zebras running across the road in the distance. "My God, don't they have wild animal regulations here?"

Brana laughed, "Yes, but the animals can't read them."

Hedy didn't laugh she was too busy squinting against the sun and seeing what looked like Lions between the trees. The Jeep was bumping along when it hit a chuck hole and Hedy yelled, "Slow down. I could bounce right out of this thing."

Brana slowed down saying, "Don't worry, I'm trained for emergencies and I'm a registered nurse now."

"I just want to know if you're a registered driver?" Brana laughed as they passed a Bean field and narrowly missed a produce truck.

"The crazy English," Hedy muttered, "they've taught these savages to drive on the wrong side of the road."

"It's the right side here," Brana said seeing storm clouds in the distance.

Just as they entered town it started raining. A brief but heavy shower left them drenched. Hedy moaned, "Water shrinks Linen."

Brana was afraid to say anything, she just kept driving then quickly pulled into her carport and jumped out to assist her mother who now looked like a wilted Daffodil with her hat drooping all around. It was useless to complain but her expression said it all.

"Usually showers don't come till later in the day," Brana apologized but added a note of optimism, "But it did cool things off."

With a condescending look and a tone even lower than before Hedy said, "Thank you." They both took two suitcases and walked into the living room. Hedy looked around, "Well; this isn't too bad. Where's your roommate?'

"Still working at the Clinic but she offered you her bedroom." Brana carried suitcases into Ziva's room then went back out for the rest of them. After she got them all in she heard bath water running and yelled through the door, "I have to go back to work now but don't worry about dinner we'll bring it home."

"Fine, Go!" Hedy shouted back.

Brana looked at the closed bathroom door, shook her head and left.

"Did you get caught in the rain?" Ziva asked when Brana walked into the Clinic.

"Yea," Brana nodded, "between the jumping Jeep and the downpour Mother's not thrilled with Africa but I told her we'd bring dinner home."

"Sure, we can pickup a roast and maybe get her some flowers or candy."

"Good idea," Brana said donning her white smock.

That evening the girls came home laden with groceries, a beautiful vase of Gladiolas and a bottle of Mumm's Champagne.

That put Hedy in a better mood and she thanked them, "How thoughtful, Brana."

"It was really Ziva's idea to get Champagne. This is Ziva Sael."

"It's nice to meet you," Ziva put her hand up and waved.

"Yes, thank you for the Champagne," Hedy held the bottle up and handed it to Ziva. "Let's have a celebration drink."

"I'll get the glasses," Ziva said going to the kitchen and

carefully popping the cork.

Hedy stirred her Champagne with a gold swizzle stick then asked, "What do you girls do here besides work?"

"Lately Ziva and I have been acting like tourists and sightseeing on some weekends. We also go shopping and last month we saw one of your old movies."

"Yes," Hedy nodded, "my films are seen all over the world but it's irritating that I don't get residuals like the TV actors do."

Ziva changed the subject, "Oh we met one of your friends here who leads Safaris. His name is Wendall Jerome and he's married to an actress named Tory Sontoug."

"Tory," Hedy said surprised, "the last time I heard about her she was going with Anak."

"Well he's coming through here again next week so you can talk to him yourself."

"Yes," Hedy said thoughtfully.

After dinner Brana lit the fireplace and they sat around sipping Crème de Menthe and talking.

Brana asked, "What made you decide to visit here? The last time we talked you said Africa was a country you had no interest in seeing."

"True but I have an interest in seeing you. Also work is scarce now and," Hedy hesitated, "and I was surprised to get a letter from my crazy first husband Gunther. I thought he died but he wrote saying he was coming to take me back home. He's still obsessed with me so I thought I'd disappear for awhile."

"Men just can't resist you, mother."

"I wish that man could. Anyway he'll never find me here."

To Brana that sounded like Hedy planned a long visit.

Hedy turned to Ziva, "What made you come here?"

"I guess I also was escaping after my fiancé was killed in the Israeli army."

Hedy nodded, "Sounds like everyone comes here to escape."

"Maybe," Ziva said thoughtfully, "but I feel the best way to serve yourself is by serving others. The world needs more kindness."

"Ha," Hedy scoffed, "people always mistake kindness for stupidity and take advantage of you."

Brana interrupted, "I think mother's life is different. Because she's a movie star she's been a target for takers."

Ziva nodded, "I understand. Fame has its disadvantages."

Hedy looked piqued, "It's not just being famous, it's people in general. I heard a story about an American soldier who felt sorry for a group of starving people so he tried to share his K-rations with them and they trampled him to death getting to the food."

Ziva knew her answer would have to be well chosen so she smiled at Brana's worried look. "The soldier should have realized that starving people are close to insanity and instead of handing them food he might have dropped it to them from above."

"Drop it to them from above?" Hedy was unimpressed, "He'd have to be a damn bird to do that."

Ziva laughed and choked on her drink and ran coughing to the bathroom.

Hedy looked at Brana, "Your roommate has strange beliefs."

"Ziva is wonderful, her beliefs aren't important to me."

"Nothings important to you, you're just like your father."

"Really? That's thought provoking."

Hedy sighed, "I'm going to bed."

Brana watched the bedroom door close and heaved a sigh of relief. How were they going to live with Hedy?

The next morning Hedy came into the kitchen and Brana was making coffee. "Brana, my baby, let me take you back to Hollywood. You could be a star."

"Thank you, but I'd rather not. Besides being a star hasn't made you happy."

Hedy threw her hands up, "I was right, you're your fathers' daughter." She turned and went back to her bedroom as Ziva came into the kitchen.

"A fight this early?" Ziva asked.

"My mother's resentful because my father's married to another man."

"Do you like your father?"

"I really don't know him but he seems nice."

"Do you respect him?"

"Respect?" Brana said thoughtfully, "Yes I respect him for having the courage of his convictions and not letting society dictate how he should live."

"Do you respect your mother?"

"I, I feel sorry for her. She could never find love. Everybody thinks cause she's a movie star she has everything but she's really just an image!"

Chapter 27

ILLUSIONS AND HAPPINESS

Rob a man of his life's illusions
and you rob him of happiness

The following Monday Wendell Jerome arrived at the Clinic with a heavy set man on the verge of collapse. He saw Brana and Ziva, "Hi Ladies, could you help my friend? He's got heat prostration."

Ziva took the man inside while Brana stayed to talk with Jerome. "My mother's here and she'd like to talk with you. Do you think you could go over to my place now? Your friend will probably be here for an hour or more."

"He's actually my wife's friend, a Producer she knew from Hollywood. His name's Sam Eagle. But I could go over and come back in an hour."

"Here's my address," Brana wrote it on a pad.

He had no difficulty finding the house but Hedy wasn't prepared for guests. She yelled through the door, "Who is it?"

"Wendall Jerome. Your daughter told me to come over. My wife is Tory Sontoug."

"Oh yes, could you wait a minute."

Ten minutes later she opened the door to find Jerome sitting on the steps smoking a cigarette.

"Come in," she said in a low sultry voice.

"Thank you," he said walking in and noticing her lavender tulle hostess gown.

"Would you like a drink?"

"Have you got a Gin and Tonic?"

Hedy looked behind the bar and found the ingredients. "How is Tory?" she asked handing him the drink.

"Great. She's healthy, happy and shops a lot."

Hedy smiled, "Do you have any children?"

"No, Tory didn't want any. She doesn't seem to have the mother instinct."

Hedy nodded while pouring herself a glass of red wine. "The last time I saw Tory she was working for and dating Anak Stanislaus."

"Yea, but I guess she got tired of waiting for him to leave his wife. But we're all friends, he was at our house for dinner a couple of weeks ago."

"Really, did he mention his old friend Gunther?"

Jerome thought a moment then said, "As I recall he did say something about a business partner named Gunther who recovered from a stroke and was back at work. They have some deals going."

"Yes," Hedy said, "Gunther was my first husband. Well you must tell Tory hello for me."

"She almost came on this Safari because her friend Sam Eagle is in the group."

"Sam Eagle, the Producer?"

"Yes, in two months he's going to do a jungle picture and he wanted Tory for one of the leads but she doesn't want to work anymore."

Hedy mused, "Tory and I are about the same age, I wonder if he'd consider me for the part?"

"Maybe, would you like to meet him?"

"Yes, but I don't want to just ask him for the part, perhaps I could come on your Safari?"

He smiled, "Hedy likes Tiger hunts?"

"I'll be hunting for a part. Perhaps if he sees me in a jungle setting he might offer it to me."

"Ok, then could you be ready tomorrow?"

"I'm so bored I could be ready in an hour."

Jerome looked at his watch, "I have to go back to the hospital and pick him up. He had a little heat prostration."

"Well, tell him Hedy is joining the Safari. I've never met him personally but I'm sure he's heard of me."

Jerome smiled, "Hasn't everybody? Listen you won't need to pack much just Khaki pants, boots and a Helmut."

"I'll go shopping after you leave and be ready before noon tomorrow."

That evening when the girls got home Hedy was standing in front of a mirror in full Safari regalia.

"Hello mother, we heard about your upcoming adventure from Mr. Jerome" Brana looked at Hedy. "Are you going to wear that outfit? It looks like a costume."

"This is actually practical," Hedy said. "The skirt is really pants and these white boots are a bit thinner than the ugly brown ones they wanted me to buy and this hat is wider and better than the pith helmut they showed me."

The wide brimmed hat had a long white scarf that Hedy wrapped around her neck and it trailed down her back. "Just because I'll be tramping through jungle doesn't mean I have to look like a tramp. I heard this director has little imagination. He can't visualize anyone in a part unless they look like the part."

Ziva came out of the kitchen with three glasses of lemonade on a tray. Ziva and Brana took their drinks and sat on the couch. Hedy took hers and sat on a chair saying, "I can't

believe the way you girls are wasting your lives here. You should be in Paris looking for rich husbands."

"Yea, a lot of good that did you," Brana laughed.

Hedy looked surprised, "Well after this Safari I'm going back to civilization. You're so foolish Brana, you could come to Europe with me. I still know royalty and we could go to parties and have fun."

"Mother, I've decided I'm going to be a doctor."

For a moment Hedy's eyes crossed then she composed herself, "Maybe that does fit you. You seem to like suffering." She got up, went to the bedroom and slammed the door.

Ziva flinched, "I wish your mother wouldn't end sentences with a slammed door."

The next morning the girls left for work without seeing Hedy. Right after they left Hedy came out of her room ready for the Safari. She had a little breakfast before the Caravan came with one Limousine and three Jeeps. She climbed into the Limo with Jerome and Sam Eagle. She had a small suitcase with her.

Jerome looked at the way she was dressed and said, "I assume you don't intend to come on the hunt with us?"

"Heavens, No. I just want to get the feel of a real Safari. I'll wait at the Campsite while you do your hunting."

Jerome nodded, "Ok and this is Sam Eagle."

"Yes, hello" Hedy smiled, "I've heard about you."

"I've heard about you too. It's a pleasure to meet you in person. I've seen your movies and you're a talented actress."

"Thank you," Hedy smiled warming to the man immediately. She turned to Jerome, "Are you going on the hunt today?"

"Yes, as soon as we pitch tents and set up a camp fire."

"Good," Eagle said, "I'm anxious to try my new rifle."

"Well it does sound exciting," Hedy said, "perhaps next time I'll join the hunt."

Forty miles later they were in dense jungle on a dirt road. "We're here," Jerome said pulling into a small clearing and stopping to unload crew, tents and supplies.

Jerome and Eagle never stopped talking about the hunt and Hedy stood around trying to look interested. "I feel so fortunate being able to experience a Safari," she said to Eagle. He nodded in her direction and kept talking to Jerome as the natives were pitching tents and getting backpacks ready for the hunt.

Jerome turned to Hedy, "We'll be gone about three hours but you'll be safe here, we have pits dug all around the campsite so if an animal gets too close they'll fall in."

Hedy shivered and nodded but looked frightened.

"But don't worry; I'll leave you a handgun just in case. When we go on the hunt you'll be here alone except for the cook. He'll be in that tent." He pointed to a tent on the other side of hers. "The pits are covered with foliage so wild animals don't see them and fall right in."

She grimaced but said, "I'll be fine" loud enough for Eagle to hear. Then she went to her assigned tent and opened her suitcase. She had packed Gin, Tonic and Tranquilizers. She took a Tranquilizer and laid down on a cot staring at tent folds above her. Christ, she thought, three days of this and I'll be ready for a padded cell. Of course it was hot and mosquitos buzzed around. She sprayed some repellent she had brought and stepped outside looking at the sky. Where was the damn rain today? She went back inside, laid down and fell asleep. Natives yelling woke her and she stumbled out of her tent bleary-eyed. Everyone was back so she walked over to Jerome.

"Did you bag a tiger?" she asked.

"No, but we spotted a couple of big ones. Maybe tomorrow we'll be lucky."

That evening Hedy and the two men sat around a campfire eating and she decided to get to the point with Eagle. "Wendell told me you're going to make a jungle picture. Do you have it cast yet?"

"Not everyone. There's a woman's part I was hoping Tory would accept but she's decided to leave the silver screen." He looked at Jerome, "I think her husband's spoiled her." He grinned.

"She spoiled herself," Jerome shot back.

"Tory and I are old friends," Hedy said, "We started acting at the same studio and we were often considered for the same roles."

Eagle looked closely at her, "Now that you mention it, I could see you in the part. If you're interested I have a working script with me that you could read."

"I'd love to."

That night Hedy took the script to bed and began reading by flashlight but her eyes got tired and she fell asleep. She awoke at ten but the men had already left. She stumbled to the outside toilet cursing flies and mosquitoes all the way. Another sweltering day she thought walking back to her tent. But the sacrifice would be worth it if she got the part.

By late afternoon she had finished the script and thought the character was perfect for her; a mother whose children had abandoned her in the wilderness. That type of suffering could bring her back to fame and fortune. By five o'clock the men were back.

Hedy walked over to hear Jerome say, "Don't worry, we almost had him today and with a little luck we'll bring the prize in tomorrow."

"Amen," Hedy muttered to herself.

Jerome continued talking to Eagle, "Tigers are crafty animals. I bet I've tracked this one before."

"Good evening, gentlemen," Hedy greeted them smiling. "Well, Mr. Eagle, I've read your script and I think that part is perfect for me."

"Good, we'll talk at dinner."

An hour later Hedy joined the men around the Bonfire. She had changed to a long flowing gold satin gown and Eagle grinned, "Well, a man doesn't see that often in the jungle."

She smiled sitting down. "I thought you might enjoy something besides Safari pants." She said demurely accepting a glass of wine from a servent. Looking at Eagle she said, "I toast you for finding a great script. I love the character, she's really me."

"Good," Eagle smiled, "if you'll return with me to London I'll do a test and hopefully we can work something out."

She beamed raising her glass again, "Here's to working together."

By the end of the dinner she had drank nearly a bottle of wine so she bid the men Goodnight and walked carefully to her tent and fell asleep with her dress on.

Chapter 28

LIFE IS A THIRD ACT

Life is a
moderately good play
with a badly written
Third Act!
Capote.

Brana was working in the clinic and wondering how her mother was holding up on Safari, when a well-dressed older man walked in and over to her.

"Are you Brana?" he asked.

"Yes, may I help you?"

"I remember you as a little girl. I'm an old friend of your mothers. Where is she?"

"Out on a Safari."

"Really? Well I'm on vacation myself and I heard she was visiting you so I thought I'd give her a surprise visit."

"Well, they're at the Moambi Camp, about forty miles out of town. You just follow the main road until it forks to the right then take that till you come to a clearing. That's the Camp."

Brana was about to ask him his name when Ziva called, "I need your help."

He said, "You go ahead and thank you." He walked out the door and Brana went to help Ziva.

Hedy awoke about eleven, got up, donned her Safari outfit and went outside. Fortunately it was cooler with a strong breeze. She looked around at the bushes and trees and hoped they'd come back with that damn Tiger so she could return to civilization. She had breakfast and washed it down with Gin and Tonic. Tonic

was supposed to keep Mosquitoes away. She glanced at her
watch, only an hour had gone by. How would she survive another
boring day? She was now anxious to start being a star again, and
wouldn't Anak be surprised. She poured herself another drink and
sat under a tree to re-read the script. But then she felt groggy and
went back to lie down in her tent. She woke up around four in the
afternoon and decided to wear the special outfit and hat she had
bought for the Safari. It would be befitting the scripts character.
She put the hat on with the flowing scarf and wrapped it around
her neck dramatically. She would be waiting at the Camp's edge
and hopefully the sun would be setting behind her as the men
returned. They would see her as an esthetic vision of beauty in the
sunset; perfect casting for the forlorn Mother.

She stepped out of her tent and squinted at the setting
sun pushing the hat down over her eyes. She didn't need watery
eyes and running mascara. Her costume was perfect, even to the
revolver strapped at her waist. How thoughtful of Jerome to leave
it for her. The wind was getting stronger as she carefully walked
to the edge of the Campsite feeling her scarf blowing behind her.
She posed herself against a large multi-branched tree and waited.
After a few minutes she stepped forward to scan the jungle and a
gust of wind blew her scarf against a branch snagging it.

"Oh hell," she muttered trying to pull the scarf off without
tearing it. But her efforts only succeeded in hooking it securely.
She was so frustrated she didn't notice the man who was now
standing behind her.

"Hello Hedy."

She turned slightly and gasped, "Gunther!"

"I've come to take you home."

"How did you find me? Get out, you're crazy."

He grabbed her scarf and pulled it tight around her neck,

"You'll never leave me again!"

She gagged but managed to wrench herself out of his grip and grab her gun. She pointed it at him, "Leave me alone or I'll kill you!"

"Hedy, you know you really love me."

She fired a shot. It pierced his stomach and he grabbed for the gun causing her to fall back into the pit breaking her neck and pulling him with her.

Twenty minutes later the men came tramping back into Camp. Eagle was ecstatic as he walked next to the Tiger that hung by its paws on a pole between two natives.

"Look at him, I'll bet he weighs 600 pounds," Eagle said proudly.

Jerome nodded then glanced around and called for Hedy. He stopped suddenly next to one of the pits and looked down at the two bodies. "Oh my God!"

He ran to one of the natives asking him for a rope and to come with him. Eagle stood stunned looking down at the crumpled bodies and seeing blood seeping onto the ground. Jerome came back with the native and had both men hold the rope while he lowered himself into the pit. "It's Hedy and a man." He knelt beside Hedy and checked her pulse then looked up at Eagle. "I think she's dead but I'll tie a rope around her waist and you two pull her up."

Eagle muttered, "Dead? What the hell happened?" as he pulled the rope with the native.

When both bodies and Jerome were out of the pit he said, "It looks like her neck is broken and he's been shot in the stomach. This scarf must have strangled her." He said holding and staring at it.

Eagle was shaking his head, "Unbelievable."

Jerome nodded, "We'd better pack up and leave immediately." He gave orders to the natives and they quickly obeyed.

"What a tragedy," Jerome said as they lifted the bodies into the back of a Jeep. He looked at Hedy and sighed, "Just when she thought her life was beginning again."

Jerome drove directly to Brana's house and when she sleepily opened the door he said, "There's been a terrible accident," he hesitated, "We need to go directly to the Clinic. I think your mothers dead."

Brana stood for a moment then whispered, "Dead?"

"I'm so sorry, we don't really know how this tragedy happened. There's a dead man too and I'm not really sure who he is. But he may have attacked Hedy and she shot him. Then she fell back into a pit and broke her neck."

Brana said, "Take her to the main Clinic and I'll be there as soon as possible." She turned to see Ziva standing behind her stunned.

Twenty minutes later Brana and Ziva walked into the Clinic and Jerome was waiting for them. "There's nothing you can do. She did break her neck. The doctor wants to know where to send the body. Do you want to send her back to Hollywood?"

Brana shook her head, "Hollywood was never really her home. I'll have her cremated and take her home with me. Send her to the Brenton Mortuary."

He nodded, "I'll tell the doctor. I also have to fill out a police report and find out who that man was."

Ziva put her arm around Brana's shoulder, "I'll drive you back home."

Once inside the cottage Brana slumped on the couch. "Oh Ziva, I can't even cry. I loved her but all I feel is pity and sorry that she died never knowing real happiness."

Ziva nodded, "I know but perhaps this is the way it should end since it seemed so hard for her to adjust to the new world that's coming."

Brana nodded then walked into Ziva's bedroom and looked at her mothers things.

Ziva didn't follow, sensing Brana wanted to be alone. Brana looked through each suitcase finding some jewelry and a Swiss bank book with $60,000 in Hedy's name. There was also a canister of film but she'd look at it some other time.

Ziva stood in the doorway, "Are you alright?"

Brana nodded, "I guess I should call my father. "But you go to bed and don't worry, I'll be okay."

Brana made the long distance call then heard Philip's voice, "Brana, how nice to hear from you. How's everything?"

"I'm still in Africa and Mother came to visit me and went out on a Safari."

"Hedy on Safari?" he laughed, "I'll bet she never does that again."

Brana sighed, "She never will. She had an accident and she's dead."

There was some static on the line and Philip said, "Excuse me, but you didn't say dead did you?"

"Yes, I'll write to you the details as soon as I find out more of what happened."

He sighed heavily, "Are you sending her body back here?"

"No, I don't think she would have liked that. She was trying not to be buried in Hollywood."

"I suppose you're right, well do you need any money?"

"I don't think so but I'll write soon. I have to go now."

"Brana," her father shouted over the static, "take care and know that I love you."

"Thank you, I love you too." She hung up feeling totally exhausted. She laid in her bed staring into the darkness then suddenly began crying with loud racking sobs.

Ziva awoke and came into her room. She hugged her saying, "It's alright, you did the best you could."

Ziva rubbed Brana's back then Brana buried her head against Ziva's breasts and sucked her nipple so hard Ziva moaned with a cry between pleasure and pain. It was so sudden but natural. They could barely see each other in the darkness. Then Ziva fell unashamed into the soft flesh between Brana's thighs. Brana began to ascend, to soar into the heavens then racing back and exploding in orgasm. Ziva was with her fusing into a mystical ecstasy and they fell asleep entwined as one.

Ziva was first to awaken and realize it had not been a dream. She kissed Brana's cheek making her groan and come awake.

"Oh," Brana sighed staring at Ziva but there were no words to express her feelings at that moment she just said, "I'll have to go to the mortuary. I'll meet you at the Clinic later."

"Are you sure you'll be alright? Please don't have any extra guilt because of last night." Then Ziva kissed her again.

"No guilt, I just want to thank you," Brana spoke with heartfelt emotion.

Ziva nodded and left.

Brana went to the Mortuary and requested a simple burial. The Mortician asked, "Would you like a small choir to sing a hymn?"

"Yes, that would be nice," Brana said as she filled out paperwork and Jerome came in.

"Brana, Ziva told me you were here. I called Tory and told her what happened. She called Anak and he said he thinks he knows who that man was. Hedy's first husband, Gunther. Anak's flying in tomorrow."

Brana nodded, "When I was a little girl we stayed with him as I recall now. But it was so long ago and I was so young I can't really remember."

"Listen," he patted her arm, "I'll let you finish here and call you later."

Chapter 29

FUTURE IS POWER

*The past can not be
changed; the future is still in your power.*

When Brana returned to the Clinic she went to the locker room and Ziva followed her, "Can I do anything for you?"

Brana smiled, shaking her head, "You've been a true friend and I do love you but I think after the funeral I'm going to leave Africa and study in Switzerland. I really do want to become a doctor."

Ziva swallowed back tears but her eyes watered, "I'm sure they'll let you do that after such a tragedy."

"Oh Ziva," Brana hugged her friend. "I'll write and maybe you could come visit me. I'm going to tell Dr. Zelski now."

Ziva nodded and whispered, "If that's what you want I understand."

Anak walked into the Clinic and asked for Brana. She came out and he extended his hand, "I'm Anak Stanislaus, a friend of your mothers. We met when you were a little girl. I've come for the funeral and to see if I could help in any way."

"Thank you," Brana said. "I just picked up my things and I'm going home."

"I'll drive you, I have a limousine waiting."

When he followed her into the house she asked, "Would you like a drink?"

"Whiskey and soda, if you have it."

Brana fixed two drinks and sat down beside him on the couch. The last rays of the Sunset were cutting streams of light through the windows.

Anak sipped his drink, "I tried to be a good friend to your mother but," he faltered, "well, I don't think she really trusted anybody. I knew Gunther and he was truly obsessed with your mother. I would guess they had an argument only this time they both lost it!"

Tears welled up in Brana's eyes and Anak put his drink down and hugged her. "If there's anything I can do just tell me. I know that in her way she really did love you so be kind to her memory and maybe you can learn from her mistakes."

Brana nodded, "I'll try."

"I'm staying at the Kenya Hotel but take my card and call me anytime."

"Thank you," Brana smiled.

"Well at least she had an exciting life but the Hollywood she knew is gone forever and now she is truly the end of an era."

Brana nodded.

He hesitated, "A, before I go did you by chance find a roll of film in her possessions?"

"Yes."

"Good, that's mine. I wanted her opinion of it but I'd like it back now."

Brana got up, "I'll get it for you."

She came back and handed it to him. "Ah, thank you," he said relieved. "Since she never called me about this I guess she didn't think it was too good. I may destroy it and look for a new project. But I'll see you at the funeral and don't forget you can call me no matter where you are."

After he left Brana started packing and made a plane reservation for the next weekend in Switzerland. When Ziva got home they had a quiet dinner.

"I'll miss you very much," Ziva said sadly.

"I'll miss you too, you're the only true friend I ever had."
She held Ziva's hand and said softly, "Our friendship is truly love
and I want you to know that I experienced that rare feeling of
enlightenment with you. In Zen it's called Satori."

Brana leaned over and kissed her lips then said, "I'm very
tired. We'll talk tomorrow." She went to her room, closed the door
and sat down at her desk to write a farewell note to Ziva. The
words poured from her heart then she folded the paper, put it in an
envelope and wrote Ziva's name on it. Sometime during the night
Brana woke and went into the kitchen to leave the envelope on the
table then she went back to sleep.

The next morning Ziva woke early and went into the
kitchen and found the note. It read, "Ziva, we talked of many
things you and I but all the time we wanted each other and finally
we were silent. You knelt above me, a falling together in pure
love. When I was a child things being hurt made me sad but it
seemed the way the world was and I thought I had not made the
world but I had to live in it. But you and I were overflowing with
tenderness. Our bodies like wings flying into and out of each
other. Women's bodies
filled with compassionate life. When death reaches out we will
hold sparkling hands for eternity."

Ziva burst into tears then went to Brana's room and threw
her arms around her. They hugged for a long time then silently
they dressed and went to the funeral Chapel.

The service was simple. Not at all like Hedy's life but
Brana listened as the Choir sang;

"When peace like a river attendeth my way, when sorrows
like sea billows roll, whatever my lot thou has taught me to say, it
is well, it is well with my soul."

When the power of love overcomes the love of power the world will find peace.

LaVergne, TN USA
07 July 2010
188622LV00005B/129/P